FLOWER SYMBOLS

The Language of Love

This book is dedicated to my children:
Rosemarie, Benjamin, Joseph,
Michael and Christopher

You are the flowers in my garden,
the trees in my forest,
and the colors in my rainbow.

FLOWER SYMBOLS

The Language of Love

DISCOVER THE MEANING OF FLOWERS
IN FOLKLORE, RELIGION AND POPULAR CULTURE

Kathleen Karlsen

Living Arts Enterprises, LLC

GRATITUDE

My deepest gratitude to my husband Andrew who has encouraged me to write and create in the midst of the responsibilities that we share raising five children. Thank you for believing in the value of self-expression.

Thank you to my friends, especially Theresa McNicholas, for the discussions of life and God and spirituality that have kept me sane through the last dozen years and more. Thank you to Edward and Eileen Francis for the warmth of their home and the joy and stability of their friendship.

Thank you to my children—Rosemarie, Benjamin, Joseph, Michael and Christopher—who have taught me everything that really matters. Thank you for your love, your smiles and your laughter.

Thank you to my brother Daniel Hinnebusch and my sisters Maureen O'Toole and Colleen Plitt for their lifelong friendships. Though we are far apart geographically, your love and support are always tangible in my world.

Thank you to my mother, Patricia Hinnebusch, who once told me that forever is defined by the intensity of one's devotion and not by the duration of one's loyalty. Thank you for allowing me to grow and change.

Finally, thank you to my father, Michael Hinnebusch, who has been a lifelong example of the highest level of discipline, determination and generosity. Without his support, I would never have had the opportunity to find my way.

Table of Contents

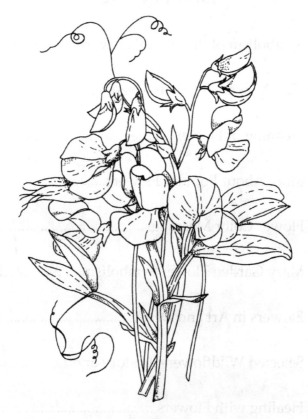

Sweet Pea

CHAPTER 1
Symbolism of the World's Favorite Flowers

Since antiquity, flower symbolism has been a significant part of cultures around the world. Flowers accompany us in every major event in life: birth, holidays, graduations, marriage, illness, and, finally, death. Flowers have been grown in decorative gardens and used as adornment for centuries on virtually every continent on earth. Finding the right flower to give to someone you love is an art. And make sure to include a note about the symbolic meaning of the flower!

Ancient Roots of Flower Symbolism
Flower symbolism began with ancient religions. Many flowers were originally linked to deities including Venus, Diana, Jupiter and Apollo. During the Renaissance, nature was viewed as a reflection of the divine. Flower symbolism was included in much of the religious art of the day and medieval gardens were often created with both the symbolic meaning of flowers and spiritual symbolism in mind. Flower symbols were used in the

religious art of the Middle Ages and Renaissance, and later reached the highest level of development in the Victorian era.

The Victorian Language of Flowers

Although the legendary associations and religious meanings of flower symbolism have existed for centuries, the use of the symbolic meaning of flowers to represent emotions was developed to a high degree during Victorian times. Due to the strict protocol of the times, emotions, wishes and thoughts were not openly expressed between men and women. Instead, an elaborate language based on flower symbolism was developed. Gifts of either single flowers or bouquets conveyed clear messages to the recipient.

During this era, flowers adorned nearly everything: hair, clothing, jewelry, home decor, china plates, stationary, wallpaper, furniture and more. Even the scents of flowers had their own meanings. For example, a scented handkerchief might be given in place of actual flowers.

With the increasing complexity of flower symbolism, handbooks were written to guide the understanding of the symbolic meaning of flowers. The first book written on flower symbolism in modern times was *Le Language des Fleurs* by Madame Charlotte de la Tour in 1819. The most popular book on flower symbolism, which remains a prominent resource today, is Kate Greenaway's *Language of Flowers* (1884).

Modern Symbolism of Flowers

Flowers have been given as gifts for special occasions and to celebrate holidays throughout history. Flowers are still used today to convey feelings in a more general way than in Victorian times. Many florists provide information on the language of flowers to encourage

the practice of helping modern gift-givers to "say it with flowers." The flower symbolism for many flowers has been obscured by time and may remain only as a few key phrases or words.

The beauty and feminine quality of flowers also inspired the tradition of naming girls after flowers. This tradition has existed in many cultures throughout history and continues today. Popular girls' names related to flowers include Rose, Daisy, Lily, Holly, Violet, Heather, Fern, Jasmine, Myrtle, and Lavender.

THE SYMBOLISM OF SPECIFIC FLOWERS

Aster Flower Symbolism

The flower symbolism associated with asters is daintiness and love. The name comes from the Greek word for "star." Asters are believed to have healing properties. Asters were laid on the graves of French soldiers to symbolize the wish that things had turned out differently. There are many varieties of asters that are popular garden plants. Asters grow in all hardiness zones. Hardiness zones are based on ten degree average temperature differences. For example, the United States and Canada are divided into eleven hardiness zones

Azalea Flower Symbolism

The flower symbolism associated with azaleas is temperance, passion, womanhood (China), take care of yourself for me and fragility. Azaleas are members of the rhododendron family. Azaleas grow as shrubs and small trees with large, showy flowers and are popular as ornamental plants in landscaping. The English name derived from the Greek word azaleos, meaning "dry."

Baby's Breath Flower Symbolism

The flower symbolism associated with baby's breath is purity of heart, innocence, and the breath of the Holy Spirit. Baby's breath is white with dense, delicate clusters of flowers. They are native to Europe, but have been naturalized throughout the eastern United States. Baby's breath is often used as ornamental garden plants and as filler in bouquets.

Bachelor Button Flower Symbolism

The flower symbolism associated with bachelor buttons is celibacy, single, blessedness, hope in love, and delicacy. The bachelor's button is also known as the cornflower, basket flower and boutonniere flower. Bachelor buttons are blue and have been prized historically for their pigment. According to folklore, a young man would wear a bachelor button flower to indicate his love for a young woman. If the love was unrequited, the flower would fade quickly. The bachelor button, or blue cornflower, is the national flower of Poland.

Bauhinia Flower Symbolism

The bauhinia flower is a symbol of harmony. The orchid-like flowers are purple-red and surrounded by thick leaves. Bauhinia flowers bloom from November to March. The Bauhinia flower is featured on the flag of Hong Kong with five petals and stars in white surrounded by a red background. Bauhinia has a double-lobed leaf similar to a heart shape.

Begonia Flower Symbolism

The flower symbolism associated with begonias is fanciful nature and beware. Begonias are large shrubs which grow in subtropical and tropical moist climates in South and

Central America, Africa and southern Asia. Because of their showy flowers of white, pink, scarlet or yellow color and often attractively marked leaves, many species and hybrids of begonias are cultivated.

Bird of Paradise Flower Symbolism

The flower symbolism associated with the bird of paradise flower is freedom, good perspective, and faithfulness (when given from a woman to a man). The bird of paradise flower is so-named because of a resemblance to the actual bird of paradise. In South Africa it is commonly known as a "crane" flower. The leaves are large and broad, similar to a banana leaf but with a longer petiole, and arranged to form a fan-like crown of evergreen foliage.

Bluebell Flower Symbolism

The flower symbolism associated with bluebells is humility, constancy and gratitude. Bluebells are closely linked to the realm of fairies and are sometimes referred to as "fairy thimbles." To call fairies to a convention, the bluebells would be rung. Bluebells can be found in North America, Western Europe and North Africa. In some areas they are referred to as wild hyacinths.

Buttercup Flower Symbolism

The flower symbolism associated with buttercups is humility, neatness, and childishness. Buttercups are part of a large genus of 400 species. Buttercups usually flower in April or May but may be found throughout the summer. In the Pacific Northwest (USA) the buttercup is called 'Coyote's eyes.' The legend is that a coyote was tossing his eyes up in the air and catching them again when an eagle snatched them. Unable to see, the coyote made eyes from the buttercup.

Cactus Flower Symbolism

The flower symbolism associated with the cactus flower is endurance, my heart burns with love, and maternal love. Cacti are distinctive and unusual plants, adapted to extremely arid and hot climates, with a wide range of features which conserve water. Their stems have expanded into green succulent structures containing the chlorophyll necessary for life and growth, while the leaves have become the spines for which cacti are so well known.

Calendula Flower Symbolism

The flower symbolism for the calendula is winning grace, grief, despair and sorrow. Calendula blossoms in wine are said to ease indigestion. Calendula petals are used in ointments to cure skin irritations, jaundice, sore eyes and toothaches.The marigold is also part of the calendula family.

Calla Lily Flower Symbolism

The flower symbolism associated with the calla lily is magnificent beauty. Calla lilies are native to southern Africa. The calla lily is visible in many of Diego Rivera's works of art. Georgia O'Keeffe's sensual flowers redefined the flower as a pure, almost geometric form.

Camellia Flower Symbolism

The symbolic meaning of camellia flowers is admiration, perfection, good luck (gift for a man), gratitude, nobility of reasoning. The colors have specific symbolic meanings including innate worth, adoration, perfection and loveliness (white); longing for a man (pink); and you're a flame in my heart or excellence (red). The English name is derived from the Latin name of the flowering evergreen shrub, camellia, which was named after the Czech-born missionary and botanist George Josef Kamel.

Carnation Flower Symbolism

The flower symbolism associated with the carnation is fascination, impulsiveness, capriciousness, joy, devoted love; disdain, and refusal (white only). Carnations were used in Greek ceremonial crowns. The name carnation may come from the Greek carnis (flesh) and refer to the incarnation of God made flesh. The English name derived from the flower name, from French carnation, meaning "complexion," from Italian carnagione, meaning "flesh-colored."

Cattail Flower Symbolism

The flower symbolism associated with the cattail is peace and prosperity. Cattails or bulrushes are wetland plants with spongy, strap-like leaves and starchy, creeping stems. The thick root can be ground to make a flour substitute. The spread of cattails is an important part of the process of open water bodies being converted to vegetated marshland and eventually to dry land

Chamomile Flower Symbolism

The flower symbolism associated with the chamomile flower is energy in action. The extract of German chamomile is taken as a strong tea. It has been used in herbal medicine as a digestive aid and has anti-inflammatory properties. It is also used in ointments and lotions, and as a mouthwash against infections of mouth and gums.

Cherry Blossom Flower Symbolism

The flower symbolism associated with the cherry blossom is education. In China, the cherry blossom is also a symbol of feminine beauty. It also represents the feminine principle and love. In Japan, cherry blossoms symbolize the transience of life because of their short blooming times. Falling blossoms

are metaphors for fallen warriors who died bravely in battle. This connotation links them with the samurai.

Christmas Rose Flower Symbolism
The flower symbolism associated with the Christmas rose is that it is purported to have flowered on Christmas Day, and is therefore associated with the infant Jesus. The Christmas Rose is a member of the genus Helleborus and is not related to the rose bush. The Christmas Rose is frost-resistant and many species are evergreens.

Chrysanthemum Flower Symbolism
The flower symbolism associated with the chrysanthemum is abundance, wealth, cheerfulness, optimism, truth (white), hope, rest, wonderful friendship, I love (red), and slighted love (yellow). The Japanese put a single chrysanthemum petal at the bottom of a wine glass to sustain a long and healthy life. Japanese emperors sat on the Chrysanthemum throne. The name is derived from the feminine form of Greek Chrysanthos, meaning "golden flower." In Italy, chrysanthemums are associated with death.

Crocus Flower Symbolism
The flower symbolism associated with the crocus is cheerfulness and gladness. The genus crocus is botanically in the iris family. The plants grow from corms and are mainly perennials. They are found in a wide range of habitats including woodland and meadows. Crocuses are native to central and southern Europe, North Africa, the Middle East, central Asia and China.

Cyclamen Flower Symbolism
The flower symbolism associated with cyclamen flowers is modesty, resignation and goodbye. Cyclamen are native in

the Mediterranean and Africa. Cyclamen grow in dry forest or scrub areas. They are part of the primrose family, although they are tuberous and bear no obvious resemblance to primroses. Cyclamen have white, pink, red or purple flowers.

Daffodil Flower Symbolism

The flower symbolism associated with the daffodil is regard, unrequited love, chivalry, sunshine, respect and the sun shines when I'm with you. Though the traditional daffodil of folklore, poetry, and field may have a yellow to golden-yellow color all over, due to breeding the daffodil may now be variously colored. Breeders have developed some daffodils with double, triple, or ambiguously multiple rows of petals, and several wild species also have known double variants. In Greek mythology, the daffodil is described as a pale yellow deathless kind of lily flower that overspreads the plains of Hades and is the favorite food of the dead. The English name is derived from the Latin asphodelus and from the Greek asphodelos. Daffodils are also known by the English name derived from the Latin juncus, meaning "rush."

Dahlia Flower Symbolism

The flower symbolism associated with the dahlia is dignity, elegance, and forever thine. The Aztecs used dahlias as a treatment for epilepsy. Europeans used the dahlia as a source of food in the 1840s when disease destroyed the French potato crop. The dahlia is named after Swedish 18th-century botanist Anders Dahl. Dahlias are often grown for flower shows.

Daisy Flower Symbolism

The flower symbolism associated with the daisy is purity, innocence, loyal love, beauty, patience and simplicity.

Daisies are often depicted in meadows in Medieval paintings, also known as "flowery meads." Daisies are believed to be more than 4,000 years old and hairpins decorated with daisies were found during the excavation of the Minoan Palace on the Island of Crete. Even further back, Egyptian ceramics were decorated with daisies. The English name is derived from the flower name, from the Old English word dægeseage, or "day's eye."

Dandelion Flower Symbolism

The flower symbolism associated with the dandelion is love me, affection returned, desire, sympathy, faithfulness, happiness and love's oracle. The dandelion is native to Europe and Asia, and has been introduced to many other places. In northern areas and places where the dandelion is not native, it has become a weed, exploiting disturbed ground in human environments.

Day Lily Flowers

The symbolic meaning of the day lily is forgetting worries. As an omen for expectant mothers who wish for baby boys, the flower means "Suited for A Boy." The Chinese also venerate the day lily as a symbol of filial devotion to one's mother.

Delphinium Flower Symbolism

The flower symbolism associated with the delphinium is big-hearted, fun, lightness, levity, and ardent attachment. The name delphinium comes from the Greek word delphis, a reference to the flower's resemblance to the bottle-like nose of the dolphin. Delphiniums were used by Native Americans to make blue dye. European settlers used delphinium for making ink. Delphiniums were also once thought to drive away scorpions.

Edelweiss Flower Symbolism

The flower symbolism associated with the edelweiss flower is daring, courage and noble purity. The flowers are felted and woolly with white hairs and characteristic blooms consisting of five to six small yellow flower heads surrounded by leaflets. Eidelweiss is a European mountain flower belonging to the sunflower family. The name comes from German edel (meaning noble) and weiss (meaning white).

Fern Symbolism

The flower symbolism associated with ferns is magic, fascination, confidence, shelter, discretion, reverie and a secret bond of love. A great many ferns are grown as landscape plants, for foliage for cut bouquets and as houseplants. Ferns do not have seeds or flowers, but reproduce by spores. There are about 12,000 varieties of ferns worldwide. The English name is derived from the Old English "fear" meaning "fern," a type of leafy plant. The name was first used in the 19th century when "dainty" names were popular.

Forget-Me-Not Flower Symbolism

The flower symbolism associated with the forget-me-not is true love and memories. In 15th century Germany, it was supposed that the wearers of the flower would not be forgotten by their lovers. In a medieval legend, a knight and his lady were walking along the side of a river. He picked a posy of flowers, but because of the weight of his armour he fell into the river. As he was drowning he threw the posy to his loved one and shouted "Forget-me-not." It is also told in pious legend that the Christ child was sitting on Mary's lap one day and said that he wished that future generations could see them. He touched her eyes and then waved his hand over the ground and blue forget-me-nots appeared.

Foxglove Flower Symbolism

The flower symbolism associated with the foxglove is stateliness and youth. Foxglove flowers have both positive and negative symbolic meanings. They are said to sometimes hurt and sometimes heal. The scientific name is digitalis, a reference to the presence of powerful chemicals that can heal heart conditions if taken correctly but can kill if taken in large amounts. Thus, foxglove is symbolic of both healing and harm.

Fuchsia Flower Symbolism

The flower symbolism associated with the fuchsia is confiding love. Fuchsia flowers are a very decorative pendulous "eardrop" shape, growing in profusion through out the summer and autumn, and all year in tropical species. In many species, the sepals are bright red and the petals purple, a combination of colors that attract hummingbirds.

Gardenia Flower Symbolism

The flower symbolism associated with the gardenia is you're lovely, secret love, purity and refinement. Gardenia plants are prized for the strong sweet scent of their flowers, which can be very large in some species. Gardenias are in the coffee family and are native to Africa, Asia, Australasia and Oceana. Gardenias also grow in Hawaii. They are shrubs or small trees. The English name is derived from the flower name, meaning simply "garden flower."

Geranium Flower Symbolism

The flower symbolism associated with the geranium is true friend, stupidity, folly and meeting. The genus name is derived from the Greek word geranos, meaning "crane." The common name derives from the appearance of the

seed-heads, which have the same shape as the bill of a crane. Geraniums are found in temperate regions of the world and in tropical mountains.

Gladiola Flower Symbolism
The flower symbolism associated with the gladiola is preparedness, strength, splendid beauty and love at first sight. The gladiola is named for the shape of its leaves, which resemble a "gladius" or sword. The gladiola is said to have symbolized the Roman gladiators. The British used the stem base (corms) as a poultice for thorns and splinters.

Globe Amaranth Flower Symbolism
The flower symbolism associated with the globe amaranth is unfading love. The globe amaranth is an annual plant that grows up to 24 inches tall. The true species has magenta flowers, and garden varieties have additional colors such as purple, red, white, pink, and lilac. The globe amaranth is a genus of plants in the family Amaranthaceae.

Hibiscus Flower Symbolism
The flower symbolism associated with hibiscus is delicate beauty. Hibiscus is a large genus containing over 200 species, including landscape shrubs (attractive to butterflies and bees), a variety used as a vegetable and another type used for paper making. The most well-known use of hibiscus is for herbal teas.

Holly Symbolism
The flower symbolism associated with the holly is defense, domestic happiness and forecast. The Romans decorated their hallways with holly garlands for their mid-winter celebration, Saturnalia. Medieval monks called the holly the Holy Tree and believed holly would keep away evil

spirits and protect their homes from lightening. The pointed leaves represented the crown of thorns worn by Jesus, and the red berries symbolized drops of his blood.

Honeysuckle Flower Symbolism
The flower symbolism associated with the honeysuckle is bond of love and I love you. Wood cuttings from honeysuckle are sold as cat toys. The wood contains nepetalactone, the active ingredient found in catnip. Honeysuckle is a twining flower grown in China, Europe and North America. Many species have sweetly scented, bell-shaped flowers.

Huckleberry Symbolism
The symbolism associated with the huckleberry is faith and simple pleasures. The tiny size of huckleberries led to their frequent use as a way of referring to something small, often in an affectionate way. The phrase "a huckleberry over my persimmon" was used to mean "a bit beyond my abilities." "I'll be your huckleberry" is a way of saying that one is just the right person for a given job.

Hyacinth Flower Symbolism
The flower symbolism associated with the hyacinth is games, sports, rashness, and playful joy. The name is derived from the Latin form of Greek hyakinthos. Hyacinths are named after Hyacinth, a figure in Greek mythology. This is the name of a youth loved by Apollo who accidentally killed him, after which the hyacinth flower sprouted from his blood. Hyacinths are sometimes associated with rebirth. The hyacinth flower is used in the Haftseen table setting for the Persian New Year celebration. The prophet Mohammad is reported to have said "If I had but two loaves of bread, I would sell one and buy hyacinths, for they would feed my soul."

Impatiens Flower Symbolism
The flower symbolism associated with impatiens flowers is motherly love. Impatiens flowers come in a wide variety of forms including flat flowers and orchid-like shapes. In the medieval Mary Gardens devoted to the Virgin Mary, impatiens plants were called "Our Lady's earrings" (see Chapter 6).

Iris Flower Symbolism
The flower symbolism associated with the iris is faith, wisdom, cherished friendship, hope, valor, my compliments, promise in love, and wisdom. Irises were used in Mary Gardens, sacred gardens created in honor of the Virgin Mary. The blade-shaped foliage denotes the sorrows which 'pierced her heart.' The iris is the emblem of both France and Florence, Italy. It is derived from the Greek name meaning "rainbow." In mythology, this is the name of a rainbow goddess. The name is in use by the English as a feminine name, and by those of Jewish heritage as a unisex name.

Ivy Symbolism
The symbolism associated with ivy is wedded love, fidelity, friendship and affection. Ivy walls are considered idyllic and charming. A soundly mortared wall is impenetrable to the climbing roots of ivy and will not be damaged, and is also protected from further weathering by the ivy. However, walls with already weak or loose mortar may be badly damaged, as the ivy is able to root into the weak mortar and further break up the wall.

Jasmine Flower Symbolism
The flower symbolism associated with the jasmine flower is attachment, sensuality, modesty, grace, and elegance.

Jasmines are widely cultivated for their flowers, enjoyed in the garden, as house plants, and as cut flowers. The flowers are worn by women in their hair in southern and southeast Asia. Some claim that the daily consumption of jasmine tea is effective in preventing certain cancers. The English name is derived from the Persian yasmin, meaning "jasmine flower," a plant in the olive family. The masculine form is Jasmin.

Lady's Mantle Symbolism
The symbolism associated with Lady's Mantle is that of a cloak for for the Blessed Virgin. Lady's mantle was grown in Mary Gardens. The name alchemilla ("little magical one") derives from the dew which collects on the lady's mantle. Dew is often associated with magic. The dew was used as a beauty lotion, while pillows stuffed with it were reputed to bring on a good sleep.

Lilac Flower Symbolism
The flower symbolism associated with the lilac is beauty, pride, youthful innocence and youth. A pale purple color is generally known as lilac after the flower. Lilacs can also be white, pale yellow, pink or burgundy. Lilacs are known for their strong, perfume-like scent and are the state flower of New Hampshire. Lilacs grow on shrubs or trees. The English woman's name is derived from the name of this flowering bush. A pale purple color is generally known as lilac after the flower.

Lily Flower Symbolism
The flower symbolism associated with the lily is chastity, virtue, fleur-de-lis, Holy Trinity, faith, wisdom, chivalry, royalty; beauty (calla), mother (China), hatred (orange), wealth, pride (tiger); sweetness, virginity, purity, majesty, it's heavenly to be with you (white); gaiety, gratitude,

and I'm walking on air (yellow). The flower symbolism of lilies is associated with the annunciation of the birth of Jesus by the angel Gabriel. In both Christian and pagan traditions, lilies symbolize fertility. In Greek marriage ceremonies, the bride wears a crown of lilies.

Lotus Flower Symbolism
The flower symbolism associated with the lotus is estranged love and forgetfulness of the past. The lotus is the national flower of India and a symbol of spiritual enlightenment, purity, rebirth and divinity. The blue or Indian lotus, also known as the bean of India, is the sacred water-lily of Hinduism and Buddhism. Lotus roots are used widely in Asian cooking. The English name is derived from the flower name, from Latin lotus, from Greek lotos, a name for various kinds of plants before it came to designate the Egyptian "white lotus." The Greek word may ultimately come from Hebrew lowt, meaning "covering, veil."

Lupine Flower Symbolism
The flower symbolism associated with lupines is imagination. The name "lupinus" actually means "of wolves" due to the mistaken belief that ancient peoples had that lupines robbed the soil of nutrients. The fact is that lupines add nitrogen to the soil. Lupines are the only food for the Karner blue butterfly's caterpillar. The scent from lupine blossoms is like that of honey, a nice addition to any garden.

Magnolia Flower Symbolism
The flower symbolism associated with nobility, perseverance and love of nature. Magnolia is the official state state flower of both Mississippi and Louisiana. The flower's abundance in Mississippi is reflected in its state nickname, the "Magnolia State." The magnolia is also the official state tree

of Mississippi. One of the oldest nicknames for Houston, Texas is "The Magnolia City" due to the abundance of Magnolia Trees growing along Buffalo Bayou.

Marigold Flower Symbolism

The flower symbolism associated with marigolds is indicated in the name: Mary's Gold. Marigold flowers were "golden gifts" offered to the Virgin by the poor who could not afford to give actual gold. Marigolds were used in Mary Gardens. Marigolds are symbolic of passion and creativity. Marigolds are also known as the "Herb of the Sun." Marigolds have been used as love charms and incorporated into wedding garlands. In some cultures, marigold flowers have been added to pillows to encourage prophetic or psychic dreams. The English name is derived from the flower name, composed of the name Mary meaning "the Mother Ray" and the word "gold." (Author's note: I have a special fondness for this flower as it is one of my father's favorites and was grown in our garden by my mother all through my childhood.)

Marjoram Symbolism

The symbolism associated with marjoram is joy and happiness. Marjoram is a somewhat cold-sensitive undershrub with sweet pine and citrus flavors. It is also called sweet marjoram. Marjoram is cultivated for its aromatic leaves, either green or dry, for culinary purposes. The tops are cut as the plants begin to flower and are dried slowly in the shade.

Morning Glory Flower Symbolism

The flower symbolism associated with the morning glory is affection. As the name implies, morning glory flowers, which are funnel-shaped, open in the morning, allowing them to be pollinated by hummingbirds, butterflies, bees, other

daytime insects and birds. The flower typically lasts for a single morning and dies in the afternoon. New flowers bloom each day during the growing season.

Narcissus Flower Symbolism

The flower symbolism associated with the narcissus is normality, stay sweet, self-esteem and vanity. The name narcissus is derived from that of the youth of Greek mythology called Narcissus, who became so obsessed with his own reflection as he kneeled and gazed into a pool of water that he fell into the water and drowned. The legend continues that the narcissus plant first sprang from where he died. The Latin form is derived from the Greek Narkissos, possibly meaning "numbness; sleep."

Nasturtium Flower Symbolism

The flower symbolism associated with the nasturtium is victory in battle and conquest. Nasturtium literally means "nose-twister" or "nose-tweaker" and refers to a genus of roughly eighty species of annual and perennial flowering plants. The Nasturtium flower's botanical name, Tropaeolum majus, is Latin for trophy, a warlike reference. Nasturtium have showy, often intensely bright flowers and rounded, shield-shaped leaves with the petiole in the center.

Orange Blossom Flower Symbolism

The flower symbolism associated with the orange blossom is innocence, eternal love, marriage and fruitfulness. The orange blossom, which is the state flower of Florida, is traditionally associated with good fortune, and is popular in bridal bouquets and head wreaths for weddings. The petals of orange blossom can also be made into a delicately citrus-scented version of rosewater. Orange blossom water is a common part of Middle Eastern cuisine.

Orchid Flower Symbolism
The flower symbolism associated with the orchid is love, beauty, refinement, many children, thoughtfulness and mature charm. Orchids have become a major market throughout the world. Buyers now bid hundreds of dollars on new hybrids or improved ones. Orchids are one of the most popular cut-flowers on the market. The English name is derived from the flower name, from Greek orkhis, meaning "testicle," from Proto-Indo-European orghi. The plant was given this name because of the shape of its root.

Pansy Flower Symbolism
The flower symbolism associated with the pansy is merriment and you occupy my thoughts. The pansy is also called the heartsease or Johnny Jump Up. The name pansy is derived from the French word pensée meaning "thought," and was so named because the flower resembles a human face. In August the pansy is thought to nod forward as if deep in thought.

Peony Flower Symbolism
The flower symbolism associated with the peony is happy marriage, romance, compassion, wealth, and prosperity. Peonies are extensively grown as ornamental plants for their very large, often scented flowers. The English name is derived from the flower name, peony, after the physician god Paeon because the flower was formerly used in medicine. Peonies tend to attract ants to the flower buds due to the nectar that forms. Peonies are herbaceous plants or woody shrubs with red, white or yellow flowers.

Petunia Flower Symbolism
The flower symbolism associated with the petunia is your presence soothes me. Dixon, Illinois is the Petunia Capital

of the world. Every year, the Petunia Festival draws thousands of visitors to the city. The streets are lined in petunias. The parade mascot is Pinky Petunia. Petunias are of South American origin and closely related to tobacco, tomatoes and chilis.

Poinsettia Flower Symbolism

The flower symbolism associated with the poinsettia has an ancient history. The ancient Aztecs considered the poinsettia to be a symbol of purity. Today, poinsettias are the most easily recognized flower symbolic of Christmas. Poinsettias are also known as the "Christmas flower" and "Mexican flame leaf." Poinsettias originally came from Mexico and Central America. According to legend, one day near Christmas a child who was too poor to buy a present for the Christ child picked a weed from the side of the road. When he reached the church, the plant blossomed in red and green flowers.

Poppy Flower Symbolism

The flower symbolism associated with poppies is beauty, magic, consolation, fertility and eternal life. The Egyptians included poppies at funerals and in burial tombs. The Greeks used poppies in the shrines of Demeter, goddess of fertility, and Diana, goddess of the hunt. Poppies denote sleep, rest and repose. In modern times, poppies have been associated with Flanders fields as an emblem of those who died in World War I. The English name is derived from the flower name, from the Latin papaver, which may be from the base word meaning "to swell."

Pussy Willow Flower Symbolism

The flower symbolism associated with pussy willows is motherhood. When grown commercially, pussy willow

shoots are picked just as the buds expand in spring, and can last indefinitely once dried. The branches can be put in vases or the buds can be used for table decoration. Pussy willows are one of the earliest signs of spring.

Rhododendron Flower Symbolism

The flower symbolism associated with the rhododendron protection, bold beauty, beware and caution. Rhododendron means "rose tree." Some species are toxic to animals and may have a hallucinogenic and laxative effect on humans, thus the symbolism related to warning and danger. Today there are over one thousand species of rhododendrons. Rhododendrons are the national flower of Nepal, the state flower of Sikkim in India, and the state flower of West Virginia and Washington in the United States.

Rose Flower Symbolism

The flower symbolism associated with roses is love, remembrance, passion (red); purity (white); happiness (pink); infidelity (yellow); unconscious beauty, and I love you. Roses were first cultivated 5,000 years ago in Asian gardens. Confucius wrote that the emperor of China owned over six hundred books on the cultivation of roses. Roses were introduced to Europe during the Roman Empire and were thereafter used for ornamental purposes. Roses are emblems of England and New York City. The name was in use throughout the Middle Ages (long before common herb and flower names became popular) and probably originated as a short form of longer Germanic names containing the word hrod, meaning "horse."

Shamrock Symbolism

The symbolism associated with shamrocks is good fortune, lightheartedness, and good luck. The shamrock is a symbol

of Ireland and a registered trademark of the Republic of Ireland. The shamrock was traditionally used for its medicinal properties and was a popular decorative motif in Victorian times. The shamrock is also symbolic of St. Patrick's Day, celebrated on March 17th.

Snapdragon Flower Symbolism
The flower symbolism associated with snapdragons is graciousness and strength. The snapdragon is important as a model organism in botanical research. Its genome has been studied in detail. The name literally means "like a nose" in Ancient Greek. Snapdragons are perennials that do best in full or partial sun.

Sunflower Symbolism
The flower symbolism associated with sunflowers is adoration. Sunflowers turn their heads to the sun, which is the origin of their common name. Sunflowers belong to the genus helianthus, a reference to Helios, the sun god. Sunflowers are native to the Americas and are the state flower of Kansas. Cultivated sunflowers can reach an incredible twenty feet in height. Sunflowers are one of the fastest growing plants in the world, increasing in height up to one foot a day. These lofty heights have resulted in the sunflower being symbolic of haughtiness as well as adoration.

Sweet Pea Flower Symbolism
The flower symbolism associated with sweet peas is bliss, delicate pleasure, good-bye, departure, adieu and thank you for a lovely time. Sweet peas were very popular in the late 1800s and are often considered the floral emblem for Edwardian England. Sweet peas are the flowers most closely connected to the month of April.

Tulip Flower Symbolism
The flower symbolism associated with tulips is fame and perfect love. The symbolic meanings also change with the color of the tulips. Red tulips mean "believe me" and are a declaration of love. Variegated tulips mean "you have beautiful eyes." Yellow tulips mean "there's sunshine in your smile." And cream colored tulips mean "I will love you forever." Tulips are the foremost national symbol of Holland, rivaling wooden shoes and windmills! The name for tulips comes from the headdress worn by many Middle Eastern peoples known as a turban or taliban. In Latin, this translates to "tulipa."

Verbena Flower Symbolism
The flower symbolism associated with the verbena flower is pray for me and sensibility. Verbena has longstanding use in herbalism and folk medicine, usually as a tea. Verbena is grown as a honey plant to supply bees with nectar. Verbena is native to both the the American continent and Europe. According to legend, verbena will protect people from vampires.

Violet Flower Symbolism
The flower symbolism associated with violets is modesty, virtue, affection, watchfulness, faithfulness, love and let's take a chance on happiness. When newly opened, viola or violet flowers may be used to decorate salads or in stuffing for poultry or fish. Soufflés, cream and similar desserts can be flavored with essence of violet flowers. The English name is derived from the vocabulary word, from Latin viola, meaning "violet color" or "violet flower."

Wisteria Flowers
The symbolic meaning of wisteria flowers is welcome, playful spontaneity and adventure. The wisteria is called "Purple Vine" in China. In one cluster, the petal shades blend harmoniously from the strong, dark purple tip to the soft, light pink at the open base. Wisteria is a woody climbing vine with about ten species. Wisteria vines climb steadily by twining themselves either clockwise or counterclockwise around any available support. Among all plants, vines are the most vivid examples of nature's playfulness. The vine is a record of the plant's adventures. Wisteria is named for the eighteenth century Philadelphia physician, Caspar Wistar.

Zinnia Flower Symbolism
The flower symbolism associated with zinnias are thoughts of absent friends, lasting affection, constancy, goodness and daily remembrance. Zinnias are the state flower of Indiana. The original zinnias were found in the early 1500s in the wilds of Mexico. They were so dull and unattractive that the Aztec name for them meant "eyesore." The common name, garden Cinderella, indicates the level of the zinnia's later transformation. Zinnias are named for the German botanist Johann Zinn.

Bare Root Planting

Bare root rose bushes
weigh less,
take up less room,
are hardy.

After the thaw,
dig a hole
wider and deeper than the roots.
Add enriched soil.

Let the root crown
above the soil line.
Tamp a saucer-rim
to catch water.

Use care:
bare root roses
are brittle.

Patricia Doherty Hinnebusch

CHAPTER 2
Find Flowers By Their Meanings

The practice of creating symbolic meaning for flowers crosses all cultural boundaries. This practice began as early as recorded history and continues to spark the imagination of mankind today. Below is a list of over one hundred and fifty of the world's best-loved flowers arranged by the thought or feeling conveyed. Since many flowers have multiple meanings, some flowers appear in more than one category. Categories below include beauty, cheerfulness, faith, freedom, friendship, good luck, happiness, hope, humility, immortality, innocence, love, passion, prosperity and truth.

Flowers Meaning Beauty
The inherent beauty of flowers themselves has made them symbols of beauty the world around. Some of these flowers grow in many climates while others grow only in a few temperature zones. As a result, there are a number of flowers meaning beauty so that each nation, people and climate can claim a flower meaning beauty for their own.

(Flowers Meaning Beauty, continued)

Acacia Flower	Hibiscus Flower	Alyssum
Honeysuckle	Apple Blossoms	Lilac
Calla Lily	Orchid	Cherry Blossom
Poppy	Daisy	Gladiolus
Rose	Amaryllis	Anemone
Cowslip	Myrtle	

Flowers Meaning Cheerfulness

Flowers have been used to encourage the ill, give hope to the grieving and bring a spot of cheer to a gloomy day for millenia. Flowers that mean cheerfulness in the language of flowers:

Chrysanthemum	Coreopsis	Crocus

Flowers Meaning Faith and Fidelity

Flowers have often been used as a symbol of true love and faithfulness. Flowers that mean faith and fidelity in the language of flowers:

Bird of Paradise	Calla Lily	Iris
Violet	Daisy	Dandelion
Compass Flower	Lemon Blossoms	Passion Flower
Veronica		

Flowers Meaning Freedom

Flowers have been used as symbols of political and personal freedom, particularly the flowers below:

Bird of Paradise	Fleur de lis (Iris)

Flowers Meaning Friendship
Flowers express the essence of friendship. Flowers can express all of the subtle variations in affection, love and true caring between old and new friends. Flowers that mean friendship in the language of flowers:

Acacia Flower	Chrysanthemum	Iris
Geranium	Honeysuckle	Arbor Vitae
Periwinkle	Snowdrop	

Flowers Meaning Good Luck
Flowers meaning good luck exist in many cultures around the world, often associated with marriage and best wishes for the happy couple. See the list below for flowers particularly associated with good luck.

| Bells of Ireland | Clover | Heather |
| Lavendar | Orange Blossoms | Shamrock |

Flowers Meaning Happiness and Joy
Flowers are often associated with happy times—births, weddings, graduations—but some can also be associated with illness or death. Below are flowers specifically meaning happiness:

Apple Blossoms	Carnation	Dandelion
Gardenia	Chrysanthemum	Hyacinth
Crocus	Corchorus	Coreopsis
Holly	Lily of the Valley	Marigold
Roses	Stephanotis	Violet

Flowers Meaning Hope

The appearance of flowers in the spring is a universal sign of hope. Particular flowers also carry the meaning of hope the whole year through. Flowers that mean hope are listed below:

Almond	Anemone	Chrysanthemum
Snowdrop	Golden Daffodil	Rose of Sharon

Flowers Meaning Humility

The fact that flowers grow close to the ground, easily trampled by the insensitive or unknowing, inherently makes them a symbol of humility. There are also specific flowers that have been recognized for their association with this quality.

Bluebell	Broom Flower	Buttercup
Poppy	Alyssum	

Flowers Meaning Immortality and Youth

Flowers that bloom perenially or in spite of hard circumstances are natural candidates for meanings related to immortality and youth. Flowers that bloom over the course of a long season or open and close with the cycles of each day are also possibilities for symbols of immortality and youth. Some flowers associated with these meanings are given below.

Amaranth	Apple Blossom	Bamboo
Foxglove	Lilac	Primrose

Flowers Meaning Innocence

The beauty, gentleness and vulnerability of flowers make them an ideal symbol of innocence. Specific flowers meaning

innocence are listed below:

Baby's Breath Chrysanthemum

Flowers Meaning Love

Flowers are the ultimate symbol of love. Single flowers and bouquets have been given by lovers to woo their sweethearts for all of recorded history. According to the highly developed Victorian tradition known as the Language of Flowers, each flower has a special meaning and can convey a myriad of emotions in a discreet but clear way. The most cherished, however, are the flowers that say "I love you." Find flowers meaning love in alphabetical order below. Some are well known. Others may surprise you.

Amaranth	Apple Blossom	Arbutus
Aster	Bachelor Button	Cactus
Campion	Carnation	Cherry Blossom
Chrysanthemum	Cinquefoil	Coxcomb
Daffodil	Daisy	Dandelion
Everlastings	Fern	Forget-Me-Not
Fuschia	Gardenia	Gladiolus
Globe Amaranth	Gloxinia	Honeysuckle
Impatiens	Iris	Lilac
Lotus	Myrtle	Orange Blossom
Orchid	Pansy	Roses
Tulip	Violet	

Flowers Meaning Passion

Flowers are often a symbol of love, and by association they can sometimes be a symbol of romantic passion as well. The flowers below are associated with ardor and passion.

Passion Flower Red Rose Azalea

Flowers Meaning Prosperity

An abundance of flowers in the home and around the home is sure to uplift the spirits and fortunes of all inhabitants! Some flowers are associated with properity simply because they grow with an aggressiveness that multiplies their numbers quickly. Others are associated with weath due to their color (yellow or yellow-orange representing gold and wealth). See the flowers below for those assiciated with prosperity.

Bamboo	Buttercup	Cattails
Chrysanthemum	Lunaria	Poppy
Peony	Daffodil	

Flowers Meaning Truth

Flowers have been used to represent concepts and abstract ideas that are difficult to outpicture in the physical realm. Both those dedicated to religions and political persuasions have used flowers to convey their ideals and aspirations. See below for a single flower meaning truth.

Bittersweet Flower	White Chrysanthemum	Water Lily

Second Spring

Long after
the pristine petals
of dogwood and pear tree
and the ruffled profusion
of azaleas
have fallen,
the pink-centered,
white-edged blooms
of the mimosa
open.

Patricia Doherty Hinnebusch

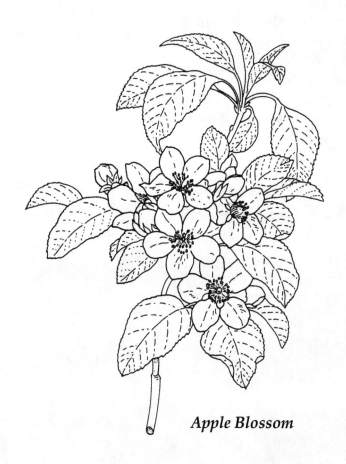

Apple Blossom

CHAPTER 3
Meaning of Flower Names

The meaning of flower names is a fascinating way to understand the origins of modern flowers and the connections to their symbolic meanings. See the alphabetical list below of the meaning of flower names.

Acacia Flower
English name derived from the tree name, from Latin acacia, from Greek akakia, meaning "thorny Egyptian tree."

Alyssum Flower
English variant spelling of Spanish Alicia, meaning "noble sort." Also from Latin alyssum and Greek alysson, meaning "not rabies," as the plant was believed to cure rabies.

Amaranth Flower
Feminine form of Latin Amaranthus, meaning "unfading."

Amaryllis Flowers
English name derived from the flower name amaryllis, from the Greek amarysso, meaning "to sparkle."

Anemone Flowers
Greek name derived from the word anemos, meaning "wind." In mythology, this is the name of a wind nymph.

Aster Flowers
Aster is from the Greek word for "star." Asters are believed to have healing properties.

Azalea Flowers
English name derived from the name of the flower, from the Greek word azaleos, meaning "dry."

Camellia Flowers
English name derived from the Latin name of the flowering evergreen shrub, camellia, named after the Czech-born missionary/botanist George Josef Kamel, from the word kamel, meaning "camel."

Carnation Flowers
English name derived from the flower name, from the French carnation, meaning "complexion," from the Italian carnagione, meaning "flesh-colored."

Chrysanthemum Flowers
This name is the feminine form of Greek Chrysanthos, meaning "golden flower." Japanese emperors sat on the Chrysanthemum throne.

Clematis Flowers
English name derived from the name of the flowering

vine clematis from Greek klema, meaning "branch or brushwood."

Columbine Flowers
English name derived from the plant name columbine, from Late Latin columbina, meaning "verbina" or "dovelike," so-called because when inverted the flower resembles a cluster of doves.

Daffodil Flowers
English name derived from the flower name, from Latin asphodelus, from Greek asphodelos, meaning "asphodel flower." In Greek mythology, it is described as a pale yellow deathless kind of lily flower that overspreads the plains of Hades and is the favorite food of the dead.

Dahlia Flowers
The English name is derived from the flower name, from the surname of Swedish botanist Anders Dahl, meaning "valley," hence "dahlia flower" or "valley flower."

Daisy Flowers
The English name is derived from the flower name, from the Old English dægeseage, "day's eye."

Delphinium Flowers
French form of Latin Delphinia, meaning "woman from Delphi." Also from the Greek word meaning "dolphin" due to its shape.

Edelweiss Flowers
The name comes from German edel (meaning noble) and weiss (meaning white).

Fern
The English name is derived from the vocabulary word fern, from Old English fear meaning "fern," a type of leafy plant. The name was first used in the 19th century when flower, plant or other "dainty" names were popular.

Gardenia Flowers
The English name is derived from the flower name, meaning simply "garden flower."

Gentian Flowers
Feminine form of Albanian Genti, meaning "gentian flower" or "(well)-born."

Hyacinth Flowers
The name is derived from the Latin form of Greek hyakinthos. In Greek mythology, this is the name of a youth loved by Apollo who accidentally killed him, after which the hyacinth flower sprouted from his blood.

Iris Flowers
Greek name meaning "rainbow." In mythology, this is the name of a rainbow goddess. In use by the English as a feminine name, and by the Jews as a unisex name.

Jasmine Flowers
The English name is derived from the Persian yasmin, meaning "jasmine flower," a plant in the olive family and the masculine form is Jasmin.

Jonquil Flowers
Daffodils are also known by the English name derived from the Latin juncus, meaning "rush."

Lavender Flowers
English color and flower name derived from the vocabulary word, from the Anglo-Saxon lavendre, from Late Latin lavendula which may ultimately derive from lividus, meaning "bluish, livid." Since 1840, the word has had the meaning "pale purple."

Lilac Flowers
English woman's name is derived from the name of this flowering bush. A pale purple color is generally known as lilac after the flower.

Lotus Flowers
The English name is derived from the flower name, from Latin lotus, from Greek lotos, a name for various kinds of plants before it came to designate the Egyptian "white lotus." The Greek word may ultimately come from the Hebrew word lowt, meaning "covering, veil."

Magnolia Flowers
English name derived from the flowering tree, named after the French botanist Pierre Magnol (1638-1715).

Marigold Flowers
The English name is derived from the flower name, composed of the name Mary, with the metaphysical meaning "the Mother Ray" and the word "gold."

Narcissus Flowers
Latin form of Greek Narkissos, possibly meaning "numbness; sleep." In mythology, this is the name of a vain youth who fell in love with his own reflection and eventually was turned into a kind of lily or daffodil flower known as the narkissos.

Nasturtium Flowers
Nasturtium flower's botanical name, Tropaeolum majus, is Latin for trophy, a warlike reference.

Orchid Flowers
The English name is derived from the flower name, from Greek orkhis, meaning "testicle," from Proto-Indo-European orghi-, the base root for for the word "testicle." The plant was given this name because of the shape of its root.

Pansy Flowers
English name derived from the flower name, from the Old French word pensee, meaning "thought."

Peony Flowers
The English name is derived from the flower name, peony, which was named after the physician god Paeon because the flower was formerly used in medicine.

Petunia Flowers
English name derived from the flower name, from French petun, an obsolete word for the tobacco plant.

Poppy Flowers
English name derived from the flower name, from Latin papaver, meaning "to swell."

Primrose Flowers
English name derived from the flower name, from Latin prima rosa meaning "first rose."

Rhododendron Flowers
Greek name meaning "rose." In the bible, this is the name of a servant in the house of Mary.

Rose Flowers
This name was in use throughout the Middle Ages (long before herb and flower names became popular) and probably originated as a short form of longer Germanic names containing the word hrod, meaning "horse."

Saffron Flowers
English name derived from the name of the spice which comes from the crocus flower, ultimately from an Arabic word meaning "yellow." Saffron is a highly prized spice and yellow dye.

Sunflowers
The name "sunflower" originates from the Greek helios meaning "sun" and anthos meaning "flower," since these flowers always turn towards the sun.

Tulip Flowers
The name for tulips comes from the headdress worn by many Middle Eastern peoples known as a turban or taliban. In Latin, this translates to "tulipa."

Violet Flowers
English name derived from the vocabulary word, from Latin viola, meaning "violet color" or "violet flower."

Wisteria Flowers
A vine with purple blossoms, named for the eighteenth century Philadelphia physician, Caspar Wistar.

Zinnia Flowers
A flower named for the German botanist Johann Zinn. The original zinnias were found in the early 1500s in the wilds of Mexico.

Shakespeare: Flower Quotes

I know a bank where the wild thyme blows,
Where oxlips and the nodding violet grows
Quite overcanopied with luscious woodbine,
With sweet musk roses and with elgantine.
A Midsummer Night's Dream, Act 2, Scene 1

There is rosemary, that's for remembrance:and
there is pansies, that's for thoughts.
Hamlet, Act 4, Scene 5

"Shall I compare thee to a summer's day?
Thou art more lovely and more temperate:
Rough winds do shake the darling buds of May,
And summer's lease hath all too short a date."
Sonnet 18

"What's in a name? That which we call a rose
By any other name would smell as sweet."
Romeo and Juliet, Act 2, Scene 2

Here's flowers for you; Hot lavender, mints,
savoury, marjoram; The marigold, that goes
to bed wi' the sun, And with him rises weeping:
These are flowers of middle summer, and I think
they are given to men of middle age.
The Winter's Tale Scene 4, Act 4

CHAPTER 4
More About Popular Flowers

More detailed information about some of the most popular flowers is included below in entries for bluebells, calla lilies, camellias, cyclamen, daisies, day lilies, impatiens, irises, lupines, marigolds, morning glories, orchids, poinsettia, poppies, roses, sunflowers, sweet peas, tulips and wisteria. This information includes growing conditions, additional lore about the flowers, fascinating historical facts and possible medicinal uses in some cases.

More About Bluebells
Bluebells have long been symbolic of humility and gratitude. They are associated with constancy, gratitude and everlasting love. Bluebells are also closely linked to the realm of fairies and are sometimes referred to as "fairy thimbles." To call fairies to a convention, the bluebells would be rung.

Bluebells are widely known as harebells in Scotland. The name originated due to the hares that frequented the fields covered with harebells. Some sources claim that witches turned themselves into hares to hide among the flowers.

Another name for bluebells is Dead Man's bells. This is due to the fact that fairies were believed to cast spells on those who dare to pick or damage the beautiful, delicate flowers. The people of Scotland are fond enough of the flower to continue this tradition in the hopes of protecting the little flower.

Bluebells can be found in North America, Western Europe and North Africa. In some areas they are referred to as wild hyacinths. Bluebells grow in forests, grasslands, mountainsides, along the ocean and in brush areas. Bluebells are members of the lily family and native to Portugal and Spain. A favorite flower around the world for many centuries, the bluebell is a particularly beloved flower in Britain.

Bluebells are easy to grow, can handle both sun and shade and even thrive in neglected gardens. Bluebells are usually grown from bulbs and reproduce by creating smaller offset bulbs as well as seeds. Bluebells will also grow in pots, tubs and urns.

Bluebells normally flower early in the year from April through June. The delicate flowers hang from a central stem. The plant also features narrow leaves in light to medium green. Many butterflies just leaving winter hibernation are fans of the bluebell's nectar.

Mountain bluebells are an edible variety of bluebells that grow in the western United States on stream bank sand in wet meadows, damp thickets and foothills in Montana, Colorado, New Mexico, Idaho, California and Oregon. The flowers can be eaten raw and the leaves can be eaten raw or cooked.

Mountain bluebells also have medicinal uses. Mountain bluebells were used medicinally by the Cheyenne Indians. An infusion of leaves was used for smallpox and

measles. An infusion of the whole plant was taken by women after childbirth to increase milk flow. An infusion of powdered roots was taken for itching from smallpox.

More About Calla Lilies

The symbolic meaning associated with the calla lily is magnificent beauty. Calla lilies are native to southern Africa. On the African island Madagascar, the calla lily thrives due to the steady temperatures and moderate seasons. Calla lilies will bloom all year around as long as they have a sufficient supply of water, energy and nutrition.

The calla lily is not actually a lily, but a separate genus. Although the calla lily was known in ancient Rome, it was first catalogued in modern times, probably in the mid 1700s, and misnamed by the famous Swedish botanist Carolus Linneaus. Later the German botanist Karl Koch found the error and established a new genus, zantedeschia, for the calla lily and related flowers. However, the original common name of "calla lily" has continued to be used.

The calla lily was used by the Romans in association with the winter solstice. The lilies were forced to bloom indoors during the darkest time of year to celebrate the preservation of the light and to bring this symbol of the light indoors. Calla lilies were often associated with funerals, only later to become a popular wedding flower.

The lily was a sacred flower to the Minoans and also prized among the ancient Jews. In Christian iconography, the flower came to represent purity, chastity and the ascension. In contrast with this, the flower's large spadix, a phallic flower stalk containing many male (pistillate) and female flowers,was symbolic of lust and sexuality among the Romans. As mentioned above, calla lilies have been viewed

as a symbol of death and associated with funerals. In this capacity, they have been placed on the graves of youth who have suffered untimely deaths.

The calla lily is a flowering genus of twenty-eight species growing mostly in marshy areas. The calla lily grows continuously in water and can survive mild frost. Calla lilies make hardy cut plants and can survive for quite a while in vases. A single calla lily in a tall vase is a classic statement of elegance and beauty.

Georgia O'Keeffe successfully brought the calla lily to prominence with her series of close-up paintings of single calla lily flowers. She wanted to have the viewer really look at the fundamental form of the flower without any preconceived notions. Her sensual flowers redefined the flower as a pure, almost geometric form. The calla lily is also visible in many of Diego Rivera's works of art.

More About Camellias

The symmetrical beauty and long-lasting qualities of the camellia have long been appreciated by young lovers as a token for expressing devotion to each other. In the eyes of the Chinese, the petals reflect the spirit of a lady, and the holder of the petals (the calyx) represents the young man entrusted by the lady as her protector.

The calyx of the camellia falls with the petals when the flower has finished blooming. This is unlike most other flowers, where the calyx seems to hang around the tree even after the petals have dropped. This phenomena symbolizes an everlasting union between lovers. In many parts of China, the camellia is considered as the flower for young sons and daughters.

The camellia is the most popular and highly respected flower in Southwest China. It was honored as the national flower for the ancient southern kingdom, Dai Li.

In a land marked by steep hills and roaring rapids, the camellia transforms the hills and valleys into oceans of red and white in early spring.

Camellias are large plants that do not need direct light. These hard, wooded plants are often grown in pots. Plants should be repotted after the dormant season before they begin to grow again.

Camellias can be repotted as often as needed and should be watered abundantly as they start to grow. Camellias should also have an occasional showering or washing to remove dust from their leaves.

Liquid manure is one of the best fertilizers to use for camellias, though it should only be applied when they are dormant or growing but not during the blossoming season. Otherwise the buds may be over stimulated and will be turned into leaves instead of flowers.

During the winter, camellias can handle a considerable amount of cold, even below freezing temperatures, for very short time periods. Once the plant has begun to grow and then to blossom, it needs a great deal of heat.

Camellias generally blossom very fully, then rest a few days or even a week. Once the flower buds have formed, the amount of water and heat can be diminished.

More About Cyclamen

The flower symbolism associated with cyclamen flowers is modesty, shyness, resignation and goodbye. This symbolism makes cyclamen especially appropriate for gifts for friends who are retiring or relocating.

Cyclamen can be grown both outdoors and indoors in pots. Cyclamen are a genus of plants containing twenty species. They are native in the Mediterranean and Africa. Cyclamen grow mainly in dry forest or scrub areas. They are part of the primrose family, although they are tuberous

and bear no obvious resemblance to primroses. Cyclamen have white, bright pink, red or purple flowers.

Some cyclamen species are endangered due to population depletion caused by those who collect them to sell on the horticultural market. Many species are now propagated in nurseries to avoid harm to the wild species.

According to folklore, cyclamen worn by a woman in labor will speed the delivery. On the other hand, caution is given to women in earlier stages of pregnancy due to the concern that they will abort their baby if they come in contact with cyclamen. Cyclamen is said to counteract poison and to make an effective ointment to heal a snake bite.

Cyclamen have been used as a powerful purgative to clear the sinuses or remove boils or blemishes from the skin, but large doses can be poisonous, so theses practices are risky. A plaster of cyclamen was reputed to be helpful for cataracts, sunburn and gout.

More About Daisies

The flower symbolism associated with the daisy is purity, innocence, loyal love, beauty, patience and simplicity. Daisies are often depicted in meadows in medieval paintings, also known as a "flowery mead." Daisies are believed to be more than 4,000 years old and hairpins decorated with daisies were found during the excavation of the Minoan Palace on the Island of Crete. Even further back, Egyptian ceramics were decorated with daisies. Daisies were used in Mary Gardens (see Chapter 6). The daisy is also symbolically connected to St. John.

The family Asteraceae (known as the aster, daisy, or sunflower family) is the largest family of flowering plants. The name 'Asteraceae' is derived from the type genus Aster, meaning star. The family comprises more than 1,600 genera

and 23,000 species. Asteraceae are most common in the temperate regions and tropical mountains.

The name daisy come from "day's eye" because the flower is only open during the day and closes up at night. Another name is "thunderflower" since it blooms in the summer when thundershowers are common. In addition, the daisy is believed to keep away lightening. For this reason, it was also kept indoors. A common name in England for the flower is bruisewort since the crushed leaves could be used for soothing bruised or chapped skin.

Commercially important plants in the daisy family include the food crops lettuce, chicory, globe artichoke, sunflower, safflower and Jerusalem artichoke. Other commercially important species include flowers used as herbs and in herbal teas and other beverages. Chamomile and calendula are grown commercially for herbal teas and the potpourri industry. Echinacea is used as a medicinal tea.

More About Lilies

In ancient times, the lily was dedicated to Hera, the wife of Zeus. A less then faithful spouse, Zeus fathered his son Hercules by the mortal woman Alceme. Although the mother was mortal, Zeus wanted his son to have divine powers, so he brought the baby to Hera while she slept to allow the baby to nurse and receive divine powers through her milk. When she awoke, she flung the child from her in wrath. Her milk spewed across the universe, forming the Milky Way. Some drops of her milk fell to earth. These drops became the first lilies.

The day lily is aptly named due to the the fact that their flowers open at sunrise and wither at sunset. Day lilies are popular worldwide, with over 60,000 cultivars. Some species of the day lily are edible and are eaten in dishes in

China including soup and stir-fry dishes. Some authorities claim that day lilies have medicinal properties.

The day lily has many names in China. When it has a cheerful position, the flower is called "Wong Yu," meaning "Forgetting Worries." As an omen for expectant mothers who wish for baby boys, the flower is called "I Nan," meaning "Suited for A Boy." Since the flower is worn by many mothers, the Chinese also venerate the day lily as a symbol of filial devotion to one's mother.

Day lilies thrive in neglected areas and have spread so widely that they are sometimes considered a native wildflower. Day lilies in the wild are sometimes called Roadside Day Lily, Railroad Day Lily or Outhouse Day Lily. Day lilies have three petals, three sepals and six stamen. Day lilies grow in clumps, have long, flat leaves and are highly adaptable as landscape flowers.

More About Foxgloves

Foxglove flowers have both positive and negative symbolic meanings. They are said to sometimes hurt and sometimes heal. In the language of flowers, foxglove is associated with insincerity.

The common name is said to come from "folk's gloves," with "folk" referring to fairy folk. Another theory is that fox wore the gloves so they would not be caught raiding a chicken coop. Rumor also has it that picking foxglove offends the fairy folk. Most likely, this tale was told to children to keep them away from the poisonous plant. Another possible origin of the name is due to its similarity to an ancient bell-shaped musical instrument, the fox's glew.

In medieval gardens dedicated to the Virgin Mary, foxglove was called "Our Lady's Gloves" or "gloves of the Virgin." The scientific name is digitalis, a reference to the presence of powerful chemicals that can heal heart conditions

if taken correctly but can kill if taken in large amounts. The danger of these compounds is reflected in other names for the foxglove, including dead man's bells and witch's gloves. The flower is fatal enough that children have died from drinking the water in a vase containing foxglove flowers.

On the positive, the digitalis from foxglove plants is used therapeutically to increase heart contractions and to regulate fast or irregular heartbeats. It is often prescribed for patients with arterial fibrillation. The active compounds are extracted from the leaves in the second year of growth. The purified chemicals are referred to as digitoxin. Too much digitalis causes anorexia, nausea, diarrhea and blurred vision.

Foxglove thrives in soil that is rich in iron and coal. New coal fields can sometimes be located by finding masses of foxgloves growing together. Foxgloves thrive in temperate zones and like shade, part shade and sun. They do not flower the first year, but flower the second and subsequent years. Their height (2-5') makes them wonderful plants for the back row of a garden. Foxglove plants often reseed themselves. They like moist soil, but also need adequate drainage. Foxgloves grow quickly and are rarely susceptible to insects. The blooms will be bigger if they are fertilized.

Foxgloves come in white, yellow, pink, rose, red, lavender and purple. Foxglove can be grown either through seeds or divisions of plant clumps. Foxgloves bloom in a pyramid shape with the lowest blossoms opening first and the buds remaining closed at the top.

More About Impatiens

Impatiens are symbolic of motherly love. In the medieval gardens devoted to the Virgin Mary, impatiens were viewed as "Our Lady's earrings." Impatiens flowers

come in many different colors from reds to blues to near blacks and browns. The individual colors have not been given separate meanings.

There are approximately 1,000 species of impatiens flowers, but only a few are normally grown in modern gardens. Many species are difficult to grow from seed. Instead, impatiens flowers are often grown from cuttings.

Impatiens come in a wide variety of forms including flat flowers and orchid-like shapes. Many species grow only in very narrow ranges and will not grow in other geographical locations. One of the unique features of impatiens is the explosive nature of the seed pods. Under extreme pressure, the ripe pods explode when they are disturbed. This scatters the seeds as much as twenty feet from the parent plant.

Impatiens also have a strange ability to change sex. The impatiens flower is male when it first opens. After a few days the pollen cap is shed and reveals female organs. This process is to keep the plant from self-pollination. However, it doesn't always work. Some species naturally set seed without even opening their flowers. Other species are self-sterile.

Impatiens come from many different ecological niches. Some forms epiphytes in trees. The plants rely on the tree for mechanical support but not nutrients, which they produce themselves. The plants are therefore not truly parasitic. Other impatiens are hardy perennials with underground rhizomes and tubers. This allows them to survive bitter freezing temperatures in arctic climates. Other impatiens are semi-aquatics that grow in edges of streams.

More About Irises
The flower symbolism associated with the iris is faith, wisdom, cherished friendship, hope, valor, my compliments, promise in love, wisdom. Irises were used in Mary Gardens.

The blade-shaped foliage denotes the sorrows which 'pierced her heart.' The iris is the emblem of both France and Florence, Italy. The fleur-de-lis, one of the most well-known of all symbols, is derived from the shape of the iris flower. The fleur-de-lis is a symbol of the royal family in France and is the state flower of Tennessee.

Iris flowers are a genus with 200-300 flowering varieties. The name is derived from the Greek word for rainbow. Irises are grown from bulbs or rhizomes and have long, flat leaves. Irises are used widely in gardens, especially the bearded varieties. Irises are easy to cultivate and propagate.

Blessed with the colors of the rainbow and the purest white, the iris has been recognized as the spirit of early summer. Its soft, fluttering petals remind the Chinese people of butterfly wings, flapping gently in the breeze. The flower is known as Tze Hu-tieh or "The Purple Butterfly."

More About Lupine Flowers

Lupines are symbolic of imagination. The name "lupinus" actually means "of wolves" due to the mistaken belief that ancient peoples had that lupines robbed the soil of nutrients. The fact is that lupines add nitrogen to the soil. The Romans used lupines for fertilizer and ate the high-protein seeds.

In the United States, lupines grow well in the Pacific Northwest, the West Coast, New England and other northern states. They are both cultivated flowers and wildflowers. Lupines also grow abundantly throughout Europe as far north as Norway.

Lupines come in blue, pink, white, yellow and purple. The flowers are useful for dyeing cloth. The seeds of lupines are said to aid digestion and have been used in skin care for removing spots from the face. The Romans used the flat seeds for theater money.

Lupines are the only food for the Karner blue butterfly's caterpillar. The larvae crawl up the stems of wild lupines to feed on the new leaves in mid-April.The scent from lupine blossoms is like that of honey, a nice addition to any garden. The magnificent flower spikes can be from 36-60 inches high. Lupines need full sun, rich soil and lots of moisture. They can grow in poor soils if the soil is not too alkaline.

More About Marigolds

Marigolds are known as the "Herb of the Sun" and are symbolic of passion and creativity. The Welsh believed that if marigolds were not open early in the morning, then a storm was on the way. Marigolds have been used as love charms and incorporated into wedding garlands. Water made from marigolds was thought to induce psychic visions of fairies if rubbed on the eyelids. In some cultures, marigold flowers have been added to pillows to encourage prophetic or psychic dreams.

The marigold is also associated with the lion and the astrological sign Leo. Early Christians named the flower "Mary's Gold" and offered the blossoms in place of money at the foot of her statues. The Portuguese introduced marigolds into India. Eventually the flower was offered to the Hindu gods Vishnu and Lakshmi. The marigold is also considered to be sacred among the Aztec Indians, who decorate their temples with the flower.

The marigold was once thought to protect against the plague and to be effective in stopping gossip. Interestingly, the marigold can symbolize cruelty and jealousy. When used in combination with spells, however, the marigold is an anti-dote for the sharp-tongued and promotes cheery conversations.

Marigolds can be found in Europe, Africa and the Americas. Marigolds can adapt to a wide range of conditions, but prefer full sun and rich soils.

The leaves of marigolds have been used to remove warts. Marigolds are also grown and harvested in Mexico to be added to chicken feed. Chickens eating marigold-enriched feed produce eggs with a deep yellow color. The flesh of chickens who have been fed marigolds also take on a rich color to make them more appealing for human consumption. The blossoms themselves are quite edible for humans, too, and are often used in egg and cheese dishes. The blossoms also make a yellow dye for fabric.

The marigold is a hardy plant with yellow, orange or rusty red blooms. Marigolds have what many people consider to be a disagreeable odor. Some varieties have been bred to be odor-free, but this negates their use as a plant that wards off insects in gardens. Marigolds are grown from seeds and range in height from 6 to 36 inches. The blossoms can be from 1/2 inch to 5 inches across.

More About Morning Glories

The star-shaped morning glory is symbolic of a single day each year in which the Chinese lovers, Chien Niu and Chih Neu, are allowed to meet. According to Chinese lore, Chien Niu was a boy star who was entrusted to take care of water buffalo in the heavenly kingdom. A girl star named Chih Neu was put in charge of seamstress duties. They fell in love, and the romance caused them to neglect their duties. In anger, God forced the young lovers to be separated on both sides of the Silver River and allowed them to meet only once during the whole year.

The morning glory is aptly named, as it blooms in the morning and dies by the afternoon. The flowers are

funnel-shaped and prefer full sun. Morning glories will grow in poor, dry soil. They are a vine flower and are highly useful for trellises where they reduce the heating and cooling costs of buildings.

Morning glories are known in China for their medicinal properties. The seeds are said to have a laxative effect. Large amounts of the seeds can also be hallucinogenic.

The water morning glory, also known as water spinach or swamp cabbage, can be eaten like lettuce. Although categorized as a noxious weed, the state of Texas allows water spinach to be grown for personal consumption.

In ancient Mesopotamia, morning glory juice was used in combination with substance from the Castilla elastica tree to make a bouncing rubber ball over three thousand years ago.

More About Orchids

The flower symbolism associated with the orchid is love, beauty, refinement, many children, thoughtfulness and mature charm. Orchids have become a major market throughout the world. Buyers now bid hundreds of dollars on new hybrids or improved ones. Orchids are also one of the most popular cut flowers on the market.

There are nearly 22,000 types of orchids and they grow in nearly every climate on earth save deserts and glaciers. There are hundreds of societies and clubs worldwide dedicated to the study and cultivation or orchids.

When gardening orchid flowers, important points to remember are that orchids can grow in cool, intermediate and warm climates. They generally do not prefer excessive direct sunlight. Many types of orchids can be grown in pots as well—just be sure they get enough moisture as the soil in the pots can tend to dry out faster than the soil in gardens.

Fertilizer can assist orchids, but they do not require full strength with most brands. For indoor plants, a plate or saucer under the plant with a little water will help to humidify the air around the orchid. Also, make sure that the temperature in your home does not drop too much at night for warm-loving orchids.

The grass orchid is a delicate orchid with a gentle fragrance. The grass orchid usually grows in wild places largely untouched by man. The grass orchid is a favorite flower in oriental brush painting.

More About Poinsettias

The ancient Aztecs considered the poinsettia to be a symbol of purity. For them, the poinsettia was the "skin flower". The plant was used to produce red dye and also medicinally to reduce fevers. Today, poinsettias are the most easily recognized flower symbolic of Christmas.

Poinsettias are also known as the "Christmas flower" and "Mexican flame leaf." Poinsettias originally came from Mexico and Central America. According to a Mexican legend, one day near Christmas a child who was too poor to buy a present for the Christ child picked a bouquet of weeds from the side of the road. When the child reached the church, the plant miraculously blossomed into beautiful red and green flowers. Beginning in the 17th century, monks in Mexico included the plant in their Christmas celebrations.

Today in the United States, December 12th is Poinsettia Day. The American monopoly of the poinsettia market began in the early 1900s. Albert Ecke moved from Germany and began selling the plant from street stands. At the time, poinsettias were more like a weedy bush, lacking in fullness and definition. His son developed a grafting technique for a fuller, more attractive plant. In the next generation, Albert's

grandson began to promote the association between poinsettias and the Christmas holidays. He sent free plants to television stations to display from Thanksgiving to Christmas and appeared on programs like The Tonight Show and The Bob Hope Show to promote the poinsettia. In the 1990s, other researchers developed their own techniques for producing beautiful poinsettias. However, the Ecke family still controlled the majority of all poinsettia propagation and sales.

The bright petals of poinsettias are actually leaves or bracts, and the flowers themselves are very small and yellow. The Mexican poinsettia is bright red, but poinsettias also come in cream, yellow, pink and peach.

Poinsettias are named after Dr. Joel R. Poinsett, a US ambassador to Mexico who introduced the plant to the United States. Recent research has shown that poinsettias are not poisonous, as they were long believed to be. Poinsettias can grow to a height of 16 feet and thrive in climates where the temperature remains between 50F and 70F degrees.

More About Poppies

The flower symbolism associated with poppies is beauty, magic, consolation, fertility and eternal life. The Egyptians included poppies at funerals and in burial tombs. The Greeks used poppies in the shrines of Demeter, goddess of fertility, and Diana, goddess of the hunt. Poppies denote sleep, rest and repose. In modern times, poppies have been associated with Flanders fields as an emblem of those who died in World War I.

Poppies represent the loyalty and faith between lovers. According to Chinese legend, a beautiful and brave woman, Lady Yee, was married to Hsiang Yu, a warrior with Herculean strength. When Hsiang led his troops into battle, Lady Yee chose to follow him and stood by his side in every battle.

During a long and arduous war, Hsiang's army was surrounded and defeat was imminent. Lady Yee tried to boost his spirits by dancing with his sword. The petals of the poppy flower reflect her spirit as she dances in the wind with the sword. When this attempt failed, Lady Yee committed suicide. A cluster of poppies sprang in full bloom from her grave site.

Poppies do best in cool climates. They are both a cultivated flower and a hearty wildflower. Although poppies are perennials, they are often grown as annuals. Poppies grow throughout Europe, the Orient and the Americas. Poppies are the state flower of California.

Poppies have been used for centuries in seasonings, medicine and health tonics. Tea from poppies has been used for its calming effect. The oriental poppy is the only poppy that contains opium, but other poppies do have mildly sedative effects. Water made from poppies is said to remove wrinkles and freshen the skin. Poppies can also be used for dye and for adding flavor and texture to breads and pastries.

Poppies should be watered moderately and kept in full sun. Poppies grow between 2 and 5' tall with blooms up to 12 inches across. Colors include scarlet red, deep orange, light orange, white, purple and pink with black centers. There are single leaf and double leaf forms.

More About Roses

More than any other flower, the rose has been prized for its beauty the world over. Symbolic associations with the rose have existed since the days of the ancient Romans and Greeks. Roses have been identified with love and passion since those times, beginning with their association with the goddesses Aphrodite, Isis and Venus. Cleopatra is said to have received Marc Anthony in a room literally knee-deep in roses.

The flower symbolism associated with roses is love, remembrance, passion (red); purity (white); happiness (pink); infidelity (yellow); unconscious beauty, and I love you. Wild roses have five petals. This has led to their symbolic connection to the wounds of Christ in Christian iconography. The rose also symbolizes the Virgin Mary herself, who was known as the "Mystic Rose."

There are fossil records dating roses back some 35 million years. Roses are native to the United States. Montana and Oregon have the oldest rose fossils. The rose has the most complex family tree of any known flower species with over 30,000 varieties.

Roses were first cultivated 5,000 years ago in Asian gardens. In the Orient, ladies carried rose petals in their purses and gentlemen made wine and herbal medicine with the flowers. Along with the name Orchid, Rose is one of the most popular names for girls in China. Confucius wrote that the emperor of China owned over 600 books on the cultivation of roses.

Roses were introduced to Europe during the Roman Empire and were thereafter used for ornamental purposes. Romans were known to carpet huge banquet halls with rose petals. Experts divide roses into two groups. "Old roses" are those cultivated in Europe before 1800. "Modern roses" have been cultivated since about the turn of the 19th century. Before cultivation, roses typically bloomed only once per year. Now roses are blooming somewhere every day of the year.

Over 4,000 songs have been written about roses. Roses are also the inspiration for everything from wallpaper to china patterns to fabric designs. Roses are a recurring theme in artwork, furniture, architecture and poetry.

Shakespeare mentions the rose at least 70 times in his plays and sonnets: "A rose by any other name would

smell as sweet" (Romeo and Juliet); "Of all flowers, me-thinks a rose is best" (The Two Noble Kinsmen) and "When I have plucked the rose, I cannot give it vital growth again" (Othello).

Roses are emblems of England and New York City. The essential oils from roses are more expensive than the essential oils of any other flower. The rose is, indeed, the queen of all flowers.

More About Sunflowers

Sunflowers are known the world around as one of the most joyous and flamboyant flowers. They are growing rapidly in popularity as cut flowers for bouquets and flower arrangements as well as garden flowers.

Sunflowers are symbolic of adoration. Sunflowers turn their heads to the sun, which is the origin of their common name. Sunflowers belong to the genus helianthus, a reference to Helios, the sun god. In the United States, sunflowers are found in the midwest prairies as well as roadsides. The sunflower generally grows in scrub land and dry areas. Sunflowers are native to the Americas and are the state flower of Kansas and the national flower of Russia. Sunflowers bloom from July through September. Sunflowers are traditionally bright yellow with a central disk of reddish brown.

The head of the sunflower actually consists of 1,000-2,000 individual flowers. Each petal is a ray flower. Sunflowers vary widely in size depending on their adaptive genetic make up, but can reach maximum heights of three to ten feet. Cultivated sunflowers can reach an incredible twenty feet in height. Sunflowers are one of the fastest growing plants in the world, increasing in height up to one foot a day. These lofty heights have resulted in the sunflower being symbolic of haughtiness as well as adoration.

The Inca Indians worshipped the sunflower as a symbol of the sun. Their priestesses wore necklaces of sunflowers made of gold. Spanish explorers took sunflowers back to Spain, where they were cultivated and hybrids were created. Eventually, they were brought to America with European explorers. Native Americans, however, already had their own sunflowers in cultivation along the shores of Lake Huron.

Sunflowers have been celebrated in poetry and song for hundreds, if not thousands, of years. One of the most famous songs referencing sunflowers is "Believe Me If All Those Endearing Young Charms" by the poet Thomas Moore:

> ...the heart that has truly loved never forgets,
> But as truly loves on to the close,
> As the sunflower turns on her god, when he sets,
> The same look which she turned when he rose.

The cheerfulness and warmth of sunflowers are perfect for a bright bouquet of flowers to set the tone in a new home or office. Sunflowers are hard to miss in any room and go with most decors. Make a strong statement with a beautiful bouquet of sunflowers!

Those who are recovering from illness will also appreciate the powerful rays of sunshine that uplift a room through a flower arrangement featuring sunflowers. Sunflowers are a reminder of the source of life and all that is good in life.

Sunflowers are always big and bold—just what you may need to send a hearty congratulations for a graduation, a feat accomplished, a new job or a successful endeavor. Think about a stunning sunflower bouquet for celebrating a big event. And don't forget that the central meaning

of sunflowers is adoration. Send something different and meaningful for Valentine's Day, Mother's Day or a special birthday. Sunflowers say "I adore you."

Sunflowers have recently been bred to produce shorter varieties for garden use. The petals were originally quite small and irregular, so efforts have also been made to increase the size and number of petals. Some double petal varieties have also been created as well as variations in the color of the center (brown to black) and even of the petals (honey, beige, pinkish cream, soft yellow, pale russet).

Wild sunflowers have multiple stems and more than one head, with the heads or flowers usually being smaller than what we are accustomed to seeing. Modern sunflowers have been bred to have a single stem and one large flower. The largest sunflower head ever recorded was 34.5 inches across, grown by Emily Martin of Maple Ridge, Canada in 1983 (Source: Guinness Book of World Records).

Sunflower seeds are highly edible and are packed with healthy fats, vitamin E, protein, fiber and minerals. Sunflower oil can be used for cooking. Sunflower sprouts can also be eaten and the seed husks can be ground and used as a coffee-like beverage. Sunflowers serve as animal food, too, mainly for cattle and birds. American settlers used the leaves of sunflowers as fodder for their livestock.

The seeds of sunflowers have also been used by Native Americans for blue or black dye and the petals for yellow dye. Fibers from the stalks can be used as cloth. Smaller sunflower varieties are often used as cut flowers for bouquets and flower arrangements.

The most famous series of paintings by artist Vincent Van Gogh is his series of sunflowers in vases. The simplicity of the sunflower form makes it a perfect chose for art projects with children. The stunning sunflower is a natural choice for home decor and crafts.

Sunflowers need plenty of direct sunlight, but should be sheltered from excessive wind due to the top-heavy flowers that may break the stems in brisk wind. Flower stems should be supported with bamboo stakes wherever possible. The soil should be kept moist and prevented from drying out completely. Plant seeds at a depth of one to two inches. Sunflowers are fully grown in about 90 days and are attractive to butterflies, bees and birds.

Although sunflower seeds can be sown in pots, they will likely need to be replanted in the garden before they reach the flowering stage. Some varieties can grow to have tap roots that are 4' deep and obviously cannot be contained in pots. Sunflowers should not be grown in grassy areas as the seeds will kill surrounding grass when they fall to the ground.

More About Sweet Peas

The language of flowers associates the following meanings with sweet peas: blissful pleasure, delicate plea- sure, good-bye, departure, adieu and thank you for a lovely time. Sweet peas derive their name from the Greek word lathyros for pea or pulse, and the Latin word odoratus meaning fragrant. Sweet peas are the flowers most closely connected to the month of April.

The name sweet pea is believed to have first been used by the poet Keats (1795-1821). Sweet peas were very popular in the late 1800s and are often considered the floral emblem for Edwardian England. Sweet peas were an im- portant part of floral arrangements for every wedding and dinner party at that time. Dried petals of sweet peas was also one of the most important ingredients for potpourris.

Sweet peas come in over 250 varieties. Annual vari- eties prefer full sun, regular watering and soil with plenty of humus. Perennial sweet peas survive in average soils with

moderate watering. Sweet peas are wonderfully fragrant and were originally grown in the fields of Sicily.

Most types grow from 1-5' tall, though some may reach 6'. Sweet peas are climbing plants that do well on supporting structures. The delicate perfume of sweet peas combined with the variety of colors available made this flower the floral sensation of the Victorian era.

Sweet peas can be used successfully as cut flowers and in corsages and boutonnieres. Sweet peas come in red, pink, blue, white and lavender. A yellow sweet pea is an elusive ideal. Due to genetic factors, a true yellow requires careful hybridization and engineering. The most famous and perhaps most important use of sweet peas was the extensive genetics studies performed by Gregor Mendel.

There are few pests or problems associated with sweet peas, but they are sensitive to too much heat. According to superstition, seeds sown before sunrise on Saint Patrick's day will have larger and more fragrant blossoms.

Unlike their edible relatives, sweet peas can be toxic in large quantities. Sweet pea flowers naturally self-pollinate while still in bud. Sweet pea festivals and garden clubs exist for true sweet pea enthusiasts. English gardeners call sweet peas the Queen of Annuals.

More About Tulips

Tulips are one of the most admired and beloved flowers the world around. Tulips are symbolic of fame and perfect love. The symbolic meanings also change with the color of the tulips. Red tulips mean "believe me" and are a declaration of true love. Variegated tulips mean "you have beautiful eyes." Yellow tulips mean "there's sunshine in your smile" and cheerful thoughts. Cream colored tulips mean "I will love you forever." White tulips symbolize heaven, newness and purity. Purple tulips symbolize royalty.

Pink tulips mean affection and caring. Orange tulips mean energy, enthusiasm, desire, and passion.

Tulips also mean eternal life and are heralds of spring. Along with crocuses and daffodils, tulips are the first flowers to blossom each year, sometimes while there is still snow on the ground nearby. Tulips are perfect for gardens that are designed to bloom from the earliest possible date. The meaning of the garden can be encoded in the choice of flower colors. For example, a white tulip garden would symbolize heaven on earth.

As the heralds of spring, tulips are popular Easter flowers. To celebrate the cycle of growth and the return of warmth and abundance after the long winter, bright bouquets featuring yellow tulips, pink tulips, orange tulips, red tulips and variegated tulips are all perfect for centerpieces and decor during the Easter season.

Due to their association with spring and new life, tulips make wonderful get well flowers. Send a bouquet with pink tulips to symbolize your affection and caring or send yellow tulips to bring cheerfulness to those recovering from illness. Orange tulips can be a great pick-me-up and source of inspiration for those who are ill.

In addition, tulips are second only to roses for love and romance. Send a bouquet featuring roses when you want to send something memorable and unique to your Valentine. Try a bouquet of pink tulips or red tulips to express your affection and love. Other good choices for Valentine's Day flowers include red and pink lilies and purple aster flowers.

For Mother's Day, the first Sunday in May, tulips can be sent as either cut flowers or a potted plant. Pink tulips are ideal for Mother's Day, expressing warmth and affection. Red tulips are another good choice. Other popular Mothers Day Flowers include carnations, daisies and yellow roses.

White tulips, peach tulips, green tulips and purple tulips have become popular choices for sympathy flowers. A bouquet with white tulips symbolizes the eternal rest of the departed. A white casket spray of tulips is both beautiful and elegant, especially when combined with white roses, carnations or lilies. A bouquet with peach tulips conveys both affection and sympathy. An arrangement including green tulips expresses the assurance of the resurrection. A wreath with purple tulips expresses heartfelt sympathy.

Tulips also have a surprisingly long history of use as wedding flowers—for table centerpieces, general wedding decor and as bridal bouquets. Cut tulips can wilt, so the stems should be relatively short and the flowers kept in water as long as possible. Tulips are an elegant and classical choice for weddings, particularly a spring wedding. Tulips with variegated colors and ruffled tulips can create a striking, modern look for a wedding centerpiece. Potted tulips or tulip bulbs can be given as wedding favors, especially red tulips symbolizing the love of the newly wedded couple. Pink tulips are also a wonderful choice for wedding flowers.

As symbols of new life, tulips are a great choice for a baby shower or as a gift for a new baby. Pink tulips (for girls) and yellow tulips (for boys) are probably the best bets. If the gender of the baby is unknown, white tulips symbolizing heaven, newness and purity would be a great choice or orange tulips meaning energy and enthusiasm. The same symbolism makes tulips perfect birthday gifts for those with spring birthdays.

The beauty and simplicity of a bouquet including tulips, especially orange tulips, makes a strong statement for congratulating others on significant accomplishments. In addition, the achieving of a major accomplishment often sets the stage for the next step or level—a sign of growth

and new opportunities that perfectly match the flower that heralds the new cycle of spring each year. Tulips are wonderful graduation gifts as well since these celebrations usually take place in the spring or early summer.

Although you might not think of tulips for the Christmas and winter holiday season, red tulips are a striking and somewhat exotic display, reminding everyone in the darkest time of the year of the coming of spring. Red tulips combine well with berries, green foliage and colorful sprays and can brighten up any holiday table or make a unique gift for those you love or an end-of-the-year thank you for business associates and clients. Consider displaying or gifting a cheery holiday bouquet featuring tulips.

Tulips are originally from Persia and were brought to the Netherlands in the 17th century. Approximately 150 varieties of tulips grow in the wild, especially in mountainous, cold regions. Once the tulip was hybrid, a vast array of colors and petal forms were created. The name for tulips comes from the headdress worn by many Middle Eastern peoples known as a turban or taliban. In Latin, this translates to "tulipa."

In the years 1636-37, tulipmania ruled in the Netherlands. Tulips were a symbol of wealth and status and were traded like currency. A bed of tulips could buy a small house. Some highly prized tulips were even more valuable and a single bulb could be traded for a large house and all of the land, furniture and other accessories.

The most highly prized tulips had breaks or stripes in their coloration. Striped tulips were actually the result of a virus transferred by aphids, which made their appearance unpredictable. When the tulip market crashed, it was similar to the stock market crash in the 20th century. Thousands of businessmen were ruined when the bubble burst. Tulips,

however, remain the foremost national symbol of Holland, rivaling wooden shoes and windmills.

Tulips need to be fertilized twice a year, especially in the spring before they blossom. Tulips also need lots of water, with watering once a week at the bare minimum. Also be aware that rabbits, squirrels and voles will uproot and eat tulip bulbs if they can. The bulbs should be planted at a depth that is three times their height. Tulips generally prefer sun but also do well under trees that give them partial shade in the hottest part of the summer.

Tulips are planted in the fall and bulbs are generally available between July and November. The huge rainbow of tulip colors available make them a certain fit for any garden. Tulips can also be grown in pots or small containers for those who have limited garden space. A terra cotta or ceramic pot is preferable to plastic. Plastic pots may overheat or have insufficient drainage. Since tulips prefer sun and will do well on sunny porches or balconies.

What the Bee Is To the Floweret
by Thomas Moore

He: What the bee is to the floweret,
When he looks for honey-dew,
Through the leaves that close embower it,
That, my love, I'll be to you.

She: What the bank, with verdure glowing,
Is to waves that wander near,
Whispering kisses, while they're going,
That I'll be to you, my dear.

She: But they say, the bee's a rover,
Who will fly, when sweets are gone,
And, when once the kiss is over,
Faithless brooks will wander on.

He: Nay, if flowers will lose their looks
If sunny banks will wear away,
'Tis but right that bees and brooks
Should sip and kiss them, while they may.

CHAPTER 5
Flower Color Meanings

Creating a beautiful garden is like painting a picture in living color. Gardening for pleasure as well as gardening to grow food is an almost universal human occupation. Achieving color harmony, contrast and effective color combinations in the garden is a fascinating art.

Flower colors can have specific meanings even for the same flower. For example, a red tulip has a different meaning than a yellow tulip. However, there are general garden color meanings that can guide the creation of a garden for a symbolic purpose. Gardens can be created in honor of a loved one who has passed on or as a celebration for a special event such as an outdoor wedding.

Knowing flower color symbolism and fascinating facts about different types of flowers will give your garden a whole new level of meaning. The next time you are planning a garden, don't forget to consider the flower color symbolism of different flowers. By doing so, you can create a garden that is a conversation piece as well as a beautiful sight to see.

Red flowers are stimulating and eye-catching. Red flowers create movement and drama. Red flowers symbolize cheerfulness and happiness. Red flowers include poppies, poinsettias, daylilies, tulips, pansies and zinnias. The color meanings of red includes pleasure, desire, vitality, will to win, love of sports and the survival instinct. The "warm" colors red, orange and yellow are considered to be stimulating colors.

Orange flowers raise the spirits and reflect the joy of sunshine. Orange flowers symbolize warmth, fire, energy and vitality. Orange flowers include marigolds, daylilies, nasturtiums, and calendula. The color meanings of orange are creativity, confidence, intuition, friendliness and the entrepreneurial spirit.

Yellow flowers are the heralds of spring. Yellow flowers symbolize the clearing away of the winter and stimulate clear thinking. Yellow flowers include daffodils, crocus, iris, daylilies, coneflowers, dandelions and chrysanthemums. The color meanings of yellow are enthusiasm, cheerfulness, sense of humor, fun, optimism and intellectuality.

White flowers symbolize purity, contemplation and innocence. Many night-flowering plants are white, symbolizing the feminine energies of the moon. White flowers include lilies, gardenias, alyssum and baby's breath. Use white to give breathing space in your garden from the intensity of bright colors demanding attention. White means purity, inner illumination and spirituality. White softens the sometimes harsh impact of red.

Pink flowers symbolize love and healing from grief, anxiety or emotional trauma. A rose garden is the quintessential pink garden. Other pink flowers include chrysanthemums, irises, daylilies, camellias, azaleas, carnations, peonies and dahlias. Pink is related to warmth and love, gentleness, beauty, and an outward orientation.

Blue flowers symbolize the peace of ocean and sky. Blue flowers are cooling and calming. Blue flowers include irises, asters, bluebells, hyacinths, periwinkles, delphiniums, anemone, bachelor buttons, forget-me-nots and morning glories. The color meanings of blue are related to freedom, strength and new beginnings. Blue skies mean optimism and better opportunities. Blue symbolizes water, the source of life.

Purple and violet colors soothe the mind and nerves. Purple helps to relieve tension and dissipate anger and violence. Purple and violet flowers include lilacs, violets, irises, pansies, sweet peas, foxglove, lupines, alium and crocuses. The color meanings of violet are the psychological quality of transformation, transmutation and the balance of power and love. Additional meanings include charisma, charm, magical abilities and tolerance.

*People from a planet without flowers
would think we must be mad with joy
the whole time to have such things
about us.*

Iris Murdoch,
A Fairly Honourable Defeat

Flowers... are a proud assertion that a ray of beauty outvalues all the utilities of the world.
Ralph Waldo Emerson

Where flowers bloom so does hope.
Lady Bird Johnson

I will be the gladdest thing under the sun! I will touch a hundred flowers and not pick one.
Edna St. Vincent Millay

Be like the flower, turn your faces to the sun.
Kahlil Gibran

*'Tis my faith that every flower
Enjoys the air it breathes!*
William Wordsworth

The violets in the mountains have broken the rocks.
Tennessee Williams

Perfumes are the feelings of flowers.
Heinrich Heine

CHAPTER 6
Mary Garden Flower Symbolism

In the late Middle Ages, depictions of the Virgin Mary in an idealized garden were common in Flemish and German paintings. The flower symbolism in the gardens depicted represented Mary's virtues and significant events in her life. Some churches began creating actual gardens devoted to Mary, the Mother of Jesus, for worshippers to visit for meditation and prayer. These gardens had both symbolic and spiritual dimensions and would include flowers based on flower symbolism associated with Mother Mary.

The enclosed garden, or "hortus conclusus," could also represent the human soul enclosed in a body or the faithful enclosed in the body of the church. Flowers relating specifically to Mother Mary that could be included in such gardens are discussed in this chapter. Although there are a few churches that still have Mary Gardens, altars dedicated to Mother Mary are more common now and can also employ flowers and flower paintings involving appropriate flower symbolism.

Laying flowers at the feet of religious statues is a traditional practice. In modern homes, silk flowers or flower

paintings in association with altars have become popular. Altars in honor of saints, religious leaders, angels or other spiritual beings can be created with flower symbolism in mind. See the list below for flower symbolism associated with Mary Gardens.

Christmas Rose: Mary Garden Symbolism
The flower symbolism associated with the Christmas rose is that it is purported to have flowered on Christmas Day, and is therefore associated with the infant Jesus. The Christmas Rose is a member of the genus Helleborus and is not related to the rose bush. The Christmas Rose is frost-resistant and many species are evergreens. The Christmas Rose of Mary Gardens bears pure white or pink flowers and are sometimes known as the Lenten Rose.

Cowslip Flowers: Mary Garden Symbolism
In medieval times, Mary was often referred to as "Our Lady." Cowslip was called "Our Lady's Keys." Cowslip is also known as marsh marigold and grows in wet, boggy places, such as marshes, fens, ditches and wet woods. Cowslip is most luxuriant in partial shade.

Daisy Flower: Mary Garden Symbolism
The flower symbolism associated with the daisy is purity, innocence, loyal love, beauty, patience and simplicity. Daisies are often depicted in meadows in medieval paintings, also known as a "flowery mead." Daisies have also been associated with the shroud of Turin.

Forget-Me-Not Flowers: Mary Garden Symbolism
The flower symbolism associated with the forget-me-not is true love and memories. There are legends that the Christ

child was sitting on Mary's lap one day and said that he wished that future generations could see them. He touched her eyes and then waved his hand over the ground and blue forget-me-nots appeared.

Foxglove Flowers: Mary Garden Symbolism

The flower symbolism associated with the foxglove is stateliness and youth. Foxglove flowers have both positive and negative symbolic meanings. They are said to sometimes hurt and sometimes heal. The scientific name is digitalis, a reference to the presence of powerful chemicals that can heal heart conditions if taken correctly but can kill if taken in large amounts. Foxglove are known as "Our Lady's Gloves."

Heartsease (Pansy) Flowers: Mary Garden Symbolism

The flower symbolism associated with heartsease is due to it's combination of three colors: white, yellow and purple. Heartsease is known as the "Herb Trinity" and was common in medieval paintings of Mother Mary. Heartsease is also known secularly as the pansy or Johnny Jump Up. The flower symbolism associated with the pansy is merriment and you occupy my thoughts. The name pansy is derived from the French word pensée meaning "thought," and was so named because the flower resembles a human face. In August the pansy is thought to nod forward as if deep in thought.

Iris Flower Symbolism: Mary Garden Symbolism

The flower symbolism associated with the iris is faith, wisdom, cherished friendship, hope, valor, my compliments, promise in love, and wisdom. The blade-shaped foliage denotes the sorrows which 'pierced her heart.' The iris is the emblem of both France and Florence, Italy.

Lady's Mantle Symbolism: Mary Garden Symbolism

The symbolism associated with Lady's Mantle is that of a cloak for the Blessed Virgin.

Lily Flower Symbolism: Mary Garden Symbolism

The flower symbolism associated with the lily is chastity, virtue, fleur-de-lis, Holy Trinity, faith, wisdom, chivalry, royalty sweetness, virginity, purity and majesty. The flower symbolism of lilies is associated with the annunciation of the birth of Jesus by the angel Gabriel. In both Christian and pagan traditions, lilies symbolize fertility. In Greek marriage ceremonies, the bride wears a crown of lilies.

Lily of the Valley Flowers: Mary Garden Symbolism

The flower symbolism associated with the lily of the valley is "Our Lady's Tears." The lily of the Valley was said to have grown where Mother Mary wept. The lily of the valley was used to decorate churches dedicated to Mother Mary and was shown growing in the grass beneath Mary's feet in paintings by Jan Van Eyck.

Lungwort Flowers: Mary Garden Symbolism

Like the lily of the valley, the flower symbolism associated with lungwort is also "Mary's Tears." The white spots on the leaves are her tear stains and the changing color of the flowers from pink to red represent her blue eyes reddened with weeping.

Marigold Flowers: Mary Garden Symbolism

The flower symbolism associated with marigolds is indicated in the name: Mary's Gold. Marigold flowers were "golden gifts" offered to Mother Mary by the poor who could not afford to give actual gold. Marigolds were also planted in Mary Gardens. They are symbolic of passion and creativity.

Peony Flowers: Mary Garden Symbolism

The flower symbolism associated with the peony is happy marriage and compassion. Peonies are extensively grown as ornamental plants for their large, often scented flowers. Peonies were often featured in medieval paintings and tapestries depicting Mother Mary.

Periwinkle Flowers: Mary Garden Symbolism

The flower symbolism associated with the periwinkle is related to references to Mother Mary as the "Star of the Sea." This connection extends to the periwinkle flower due to its blue, star-shaped flowers. The periwinkle grows as a shrub.

Pinks: Mary Garden Symbolism

The flower symbolism associated with pinks is that of the Virgin's premonition of Christ's Passion. Also known as the Gilly Flower, they are said to have appeared when Mother Mary wept at the Crucifixion. The Madonna of the Pinks (circa 1506-1507) is an early devotional painting by the Italian Renaissance master Raphael.

Primrose Flowers: Mary Garden Symbolism

The primrose is associated with the month of May and was used to decorate altars for May Day, a celebration in which statues of Mother Mary are crowned with garlands of flowers. There are approximately two dozen different types of primroses including garden flowers and wild varieties.

Roses: Mary Garden Symbolism

The flower symbolism associated with roses is love, remembrance, passion (red); purity (white); happiness (pink); infidelity (yellow); unconscious beauty, I love you. The rose symbolizes the Virgin Mary herself, who was known as the "Mystic Rose."

Rosemary: Mary Garden Symbolism

The pale blue flowers of rosemary are said to have taken their color from Mother Mary's veil when she spread it over a rosemary bush. Rosemary has a very old reputation for improving memory, and has been used as a symbol for remembrance (during weddings, war commemorations and funerals).

Snowdrops: Mary Garden Symbolism

The snowdrop flower is also known as "Our Lady's Bells" and is used during Candlemas, a celebration of the The Feast of the Presentation of Christ in the Temple, also known as The Purification of Saint Mary the Virgin, which is on February 2nd. Snowdrops are among the first bulbs to bloom in spring.

Star of Bethlehem Flowers: Mary Garden Symbolism

The Star of Bethlehem is a reminder of Jesus' birth at Christmas. The Star of Bethlehem grows from a bulb and is native to southern Europe. The Star of Bethlehem has grass-like basal leaves and a slender stalk, up to 30 cm tall, bearing clusters of star-shaped white flowers striped with green.

Violet Flower Symbolism: Mary Garden Symbolism

The flower symbolism associated with violets is modesty, virtue, affection, watchfulness, faithfulness, love and let's take a chance on happiness. The violet's color, delicacy, sweet scent and heart-shaped leaves refer to Mary's constancy, modesty and innocence. The violet is also known as "Our Lady's Modesty."

Wild Strawberry: Mary Garden Symbolism

The wild strawberry is designated as the fruit of the Virgin Mary and of blessed souls in heaven. Wild strawberries are

depicted growing in the grass beneath the Virgin's feet in paintings by Jan Van Eyck.

Late Bloomers

Truant seeds
find their feet and eyes,
their leafage strident
between the careful rows.
they grow to giant stalks,
counting their own days,
like dreams denied
that push their way
into the poems of middle age.

Patricia Doherty Hinnebusch

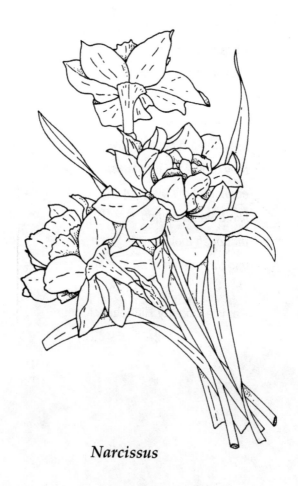

Narcissus

CHAPTER 7
Flowers in Art and Decor

Flowers are among the most ancient objects used for symbolic and decorative purposes. Flowers themselves appear to have been around practically since the beginning of time. Paleobiologists had found flower fossils dating back 120 million years. More importantly, archeologists have uncovered a grave site in a cave in Iraq that indicates that Neanderthals of the Pleistocene cave-dwelling epoch may have placed bunches of flowers on grave sites. The pollen found at the grave site indicates that a wide range of flowers were present as part of the burial ritual.

In ancient Rome, flower festivals were held in honor of the goddess Flora. Both men and women were awarded flower wreaths for victory in athletic competitions. For the Romans, the rose was associated with the goddess Venus. Nero, the Roman emperor in the 1st century AD, literally used tons of rose petals to impress his dinner guests. Cleopatra had her living quarters filled with rose petals to impress Marc Anthony. Roman women believed that roses would remove wrinkles if used in poultices. Rose petals were also dropped in wine to counteract drunkenness. Victorious Roman armies were showered with rose petals as they paraded through the streets.

Rose wreaths have also been unearthed in ancient Egyptian tombs. In addition, Confucian and Budhist religious documents contain references to roses. The lotus also played an important symbolic role in the ancient Egyptian religion.

Flowers have practical purposes as well as symbolic and religious ones. Flowers are the reproductive part of angiosperms or flowering plants. Flowers consist of the exterior petals, the central pistil and the surrounding stamen. Some flowers are self-pollinating, while others require insects, wind or other means of cross-pollination. Flowers are sources of food for both animals and insects.

The incredible beauty of many flowers have given them their added importance as decorative objects. Flowers are also an almost endless source of inspiration for poetry, stories and myths. With the importance of flowers as far back as we can trace the life of man, it is understandable that all forms of art have involved flowers on some level: sculpture, books, music, interior design, painting, ceramics, decorative tiles, mosaics, and so forth.

During the Medieval and Early Renaissance Ages from the 13th to the 15th century, flower symbolism and plant symbolism developed as a way of teaching religious truths. For example, the ivy is an evergreen and symbolized eternal life. A peach symbolized truth and salvation and was used in place of the maligned apple of Adam and Eve.

Flower paintings gained in popularity in the 17th through 19th centuries. Historically, flower paintings had generally symbolized the romantic notion that the delights of this world are transitory and perishable. This was in keeping with many centuries of art that focused on the joys of the next world and the trials and tribulations of this one. However, this began to change in the Victorian era and with advent of the Impressionists.

Flower paintings were everywhere: murals, fabrics, costumes, calligraphic art, illustrations, interior accessories and more. The unending variations of flower forms kept the interest in flower paintings high as new flowers were imported from the East and the New World.

The Victorian language of flowers is an example of detailed symbolism invested in a particular subject. As noted elsewhere in this book, not only do red roses symbolize love, but also each color has a unique meaning. For example, yellow roses convey joy and friendship, while pink roses represent happiness.

Famous Artists Depicting Flowers

The most extraordinary creator of flower paintings in the late 18th and early 19th centuries was Pierre-Joseph Redouté. Born into a family of painters, Redouté was an artistic prodigy who left home at the age of thirteen to seek his fortune as a painter of portraits and religious themes. After discovering the flower paintings of Dutch painters Brueghel and Ruysch during his travels, Redouté turned to creating flower paintings himself.

When he reached Paris, Redouté was mentored by Gerard Van Spaendock. Van Spaendock was also a Dutch painter and was the official Royal Professor of Painting for the French court. In addition, Redouté was tutored by Charles L'Heritier, a French aristocrat and botanical expert. After teaching Redouté about plant anatomy, he commissioned him to illustrate a book on botany.

Redouté's reputation as a painter of flowers was reaching great heights. Soon he was appointed as the official court painter for Queen Marie Antoinette. After the revolution, Redouté enjoyed the patronage of Empress Josephine. The Empress loved both flowers and art and created gardens with a fantastic variety of beautiful plants and flowers.

All of this aided Redouté, who produced extraordinary flower paintings for a number of books during this time.

His acclaim for his flower paintings reached it's pinnacle with the sale of a book dedicated to the illustration of roses. Redouté used a stipple engraving technique that resulted in incredible detail and subtle color variations. The book was sold to French aristocracy in monthly installments of four flower painting images for three years, at which point the book was permanently bound.

Eventually Redouté moved into flower paintings emphasizing aesthetics rather than botanical accuracy and continued in this vein until his death at the age of eighty. Redouté's flower paintings can still be found today as books, posters and even decorative stickers.

The art of the Impressionists, the best-selling and most beloved art style for almost a century and a half, often features flowers, outdoor scenes or still lifes. The impressionistic style consists of placing patches or pieces of color next to one another rather than completely blending them as was done in the classical style. This particular style capitalizes on the natural movements of the human eye.

The color placement in Impressionistic art causes the eye of the viewer to move rapidly back and forth, mimicking the way that our eyes function in an outdoor environment. We are comforted and healed at a very deep level by the movement of leaves as the wind rustles through the trees or the flickering of sunlight on a pond. This shimmering effect is replicated in the impressionistic style. The result is calming, soothing and inherently a form of healing art.

The flower paintings of Impressionist Edouard Manet are characterized by loose brush strokes, simple forms and contrasting colors. Manet's style rejected the careful shading and color transitions of botanical illustrations in

favor of a fresh look that unabashedly declared the role of artistic interpretation to be more important than careful accuracy.

Manet also used outlining and strong lighting contrasts in his flower paintings and art depicting a myriad of subjects. He also rejected the tradition of deep space and perspective that had been prominent in art for centuries. His works, including his flower paintings and other still-life images, stayed near the surface of the painting, emphasizing the materials of art rather than the illusions of art.

Claude Monet is the most famous of all of the Impressionists for his self-created outdoor studio—the gardens at Giverny. Monet had moved to Giverny five years after the death of his wife Camille and immediately after the death of his friend and mentor, Eduoard Manet. Monet was immediately taken by the blooming apple trees and pink stucco farmhouse. Monet rented the farmhouse for seven years before purchasing the property for himself.

Monet began creating his flower gardens, including a pond and bridge, for his own pleasure. Soon, however, he recognized the potential inspiration for his art work. As the gardens increased in complexity and size, Monet began to create flower paintings almost exclusively.

For the next forty years, Monet's flower paintings consumed his attention. As he grew more successful, he employed full-time gardeners to allow him to spend all of his own time on his flower paintings. Monet's flower paintings are bright and colorful. Each piece of color is distinct brush stroke. The result is a shimmering effect that has helped to keep his flower paintings among the most popular and recognizable images of all time.

As Impressionism gave way to the modern era, artists continued to emphasize the sensory pleasure of flower paintings over the symbolic meaning of flowers.

Flower paintings had been considered inferior to landscape and portrait painting, but now began to take on a new level of expression.

This is particularly true in the case of Van Gogh, whose flower paintings treated each blossom as if it were a full-fledged portrait. Van Gogh is most famous for his flower paintings featuring sunflowers, but he also painted a number of other flowers in his still-life works.

The continuing emergence of abstract art threatened the place of flower paintings in realism. Although the prosaic gardenscapes and still-life images traditional in flower paintings were relegated to the past during this period, the versatile forms of flowers actually revealed tremendous potential for more abstract images.

Georgia O'Keeffe successfully returned the flower to prominence with her series of close-ups of calla lilies. She wanted to have the viewer really look at the fundamental form of the flower without any preconceived notions. Her sensual flowers redefined the flower as a pure, almost geometric form. Georgia O'Keeffe's "Calla Lilies with Red Anemone" (1928) was sold in 2001 for $6.2 million.

The serial images of flowers created by Andy Warhol placed flower paintings squarely in the modern era. Andy Warhol's flower art was based on photographs and usually contained a limited number of flowers with a very basic, five-petal form.

Warhol's flower paintings series experimented with different color combinations for flowers with little depth or other images in the background. The focus was completely on the simple motif of the flower itself.

Warhol established the flower as a thoroughly modern subject, a status it has enjoyed ever since. Warhol also created a gender equality for flower paintings. Both men

and women artists today view flower paintings as a motif worthy of their time and attention.

The Use of Flower Art in Decor

Keep in mind that artwork for interior decor can be chosen with flower symbolism in mind. Choosing an image or gift based on flower symbolism for yourself or someone you love encapsulates the values or feelings that you want to convey.

Researchers are now also discovering the therapeutic value of positive visual symbols in healing art. This symbolism can be a part of healing art due to the colors utilized, the subjects depicted or the patterns of eye movement created in the viewer. Flowers are among the more prominent forms of symbolism that can add healing value to art.

The appeal of flower paintings and flowers in all forms of decor is timeless and crosses all national boundaries. Top publishers continue to find that flower paintings are successful in nearly all markets and in nearly all price ranges. Not only do flower paintings cross all demographic groups by income and education, but flower paintings appeal to people in all age groups as well.

Over sixty percent of all decorative retail art is flower paintings. The wide range of forms from the simple and bold to the complex and delicate ensure a remarkable diversity in flower paintings. Although roses are a perennial favorite, retailers agree that just about any flower painting will appeal to a certain segment of the population. It appears that flower paintings will continue indefinitely to be a "growing" market.

*When you have only two pennies left in
the world, buy a loaf of bread with one,
and a lily with the other.*
Chinese Proverb

*Flowers have an expression of countenance
as much as men or animals. Some seem to
smile; some have a sad expression; some
are pensive and diffident; others again are
plain, honest and upright, like the broad-
faced sunflower and the hollyhock.*
Henry Ward Beecher

CHAPTER 8
Selected Wildflowers: History and Lore

Wildflowers have always captured the imagination and symbolize both beauty and freedom. Wildflowers have been depicted in art for millennia. Wildflower paintings often appeal to both men and women, whereas garden flowers are often the realm of women. You may want to keep this in mind when choosing paintings for your home or office!

In addition, images of local wildflowers help to give a sense of purpose and belonging. For example, studies have shown that immigrants adapt more quickly to new surroundings if they have a garden or place where plants and flowers native to their place of origin are growing.

The information in this chapter will give you a better understanding of the properties and uses of selected wildflowers. Many of these flowers have been important to native peoples and have fascinating uses and histories. Wildflowers can add both beauty and meaning to your life and decor.

Beargrass Wildflowers: The Basket Plant
Beargrass wildflowers are an evergreen herb in the lily family. Colonies of the perennial beargrass wildflower,

also known as squaw grass, soap grass and Indian basket grass, bloom in 3-7 year cycles. The tall flowering stalks can be up to six feet tall with numerous small white flowers. The conical shape of the flowers makes beargrass wildflowers easily recognizable.

Beargrass wildflowers are an important part of the ecosystem in the Rocky Mountains, the Sierra Nevada and Coast ranges. Beargrass wildflowers do well in fairly dry, cool sites. Beargrass wildflowers provide food for at least 40 species of insects, who in turn pollinate the grass. Many big game animals including deer and elk also favor beargrass wildflower. Pocket gophers and other rodents feed on beargrass wildflowers and grizzly bears sometimes use beargrass wildflowers as winter nesting material in their dens.

Beargrass wildflowers have long, thin leaves with toothed edges extending from the base. The central stalk has short, leaf-like extensions along its length. Beargrass wildflowers are an important part of fire ecology and thrive with periodic burns. Beargrass wildflower rhizomes survive fires that clear plant matter from the surface of the ground. As a result, beargrass wildflowers are often the first plant to sprout in burned areas.

Beargrass wildflowers are best known for its use by Native Americans as a basket weaving material. The fibrous leaves turn from green to white as they dry and are tough and durable. The leaves may also be dyed and are flexible enough to be woven into tight, waterproof weaves. Eastern prairie tribes also used the boiled roots of beargrass wildflowers as a hair tonic and to treat sprains.

Beargrass is still used today for basket weaving. More recently, beargrass wildflowers have become an important long-lasting green in floral bouquets. Many national forests are now issuing permits for the harvest-

ing of beargrass wildflowers for commercial use. Beargrass wildflowers can be grown in gardens in well-drained soils. Don't over-water and do not use commercial fertilizers. Humus and a tree needle mulch will make your beargrass wildflowers feel right at home.

Bitterroot Wildflowers: The Resurrection Flower

The bitterroot wildflowers have been a Montana icon for centuries. Also know as the "resurrection flower," the plant is legendary for its ability to live for more than a year without water. The stem of bitterroot wildflowers are so short that the flower seems almost to sit on the ground. In addition, the leaves die off when the flower blooms, leaving the appearance of a flower emerging directly from the soil. For this reason, bitterroot wildflowers are also called rock-roses. As he passed through Montana, Meriwether Lewis collected bitterroot wildflowers on the famous Lewis and Clark expedition.

The bitterroot wildflower became Montana's state flower by popular vote in 1895. Bitterroot wildflowers have lent their name to a mountain range, a river and the famous Bitterroot Valley. Each year a two-day annual bitterroot wildflowers festival takes place in this valley to celebrate the versatile bitterroot plant.

Bitterroot wildflowers are low-growing perennials with fleshy taproots and a branched base. Bitterroot wildflowers blooms in May and June. Each bitterroot wildflower plant has a single flower ranging in color from white to a deep pink or rose.

The root of bitterroot wildflowers were considered a luxury by the Native Americans and could be traded with other Indian tribes as well as with pioneers and trappers. A sack of the valuable prepared roots could be traded for as much as horse.

Bitterroot wildflowers were an important part of the diet of Montana Indians. Many Montana tribes—including the Flathead, Spokane, Nez Perce, Kalispell and Pend d'Oreille—timed their spring migration with the blooming of bitterroot wildflowers. The roots were gathered near what is now Missoula. After being cleaned and dried, the roots were a nutritious, lightweight snack. The roots were cooked before eating and usually mixed with meat or berries. Cakes of the cooked root could be carried and eaten while traveling.

Owl-clover Wildflowers: A Western Favorite

Owl-clover wildflowers are a member of the snapdragon family (scrophulariaceae, Orthocarpus). This family numbers 4500 species around the world. The name Orthocarpus is from the Greek orthos, "straight," and karpos, meaning "fruit."

Owl-clover wildflowers are closely related to the Indian paintbrushes. The origin of the common name is obscure, though owl-clover wildflowers do somewhat resemble the head and feathers of an owl. Owl-clover wildflowers are not directly related to other types of clover. Owl-clover wildflowers grow on low ground in dry, open sites such as meadows in most parts of Montana. Owl-clover wildflowers also grow in Canada, Minnesota, California, Nebraska, New Mexico and northwestern Mexico.

Owl-clover wildflowers are winter annuals six to eight inches tall. The yellow, white or purple "petals" are actually bracts (a leaflike structure) surrounding very small, nearly hidden yellow flowers. The leaves alternate along the stalk and may have two narrow side lobes. The owl-clover wildflowers are on narrow spikes and bloom a few at a time. A single owl-clover wildflower plant may have dozens of blooms during a full growing season. Owl-clover

wildflowers are a partial parasite that relies on the root system of other plants.

Owl-clover wildflowers are mentioned in the journal of Meriweather Lewis on July 2, 1806. Owl-clover wildflowers were later fully described in 1818 by the the English botanist Thomas Nuttall during explorations of what is now North Dakota.

Indian Paintbrush Wildflowers: Wyoming State Flower

Indian paintbrush wildflowers can be orange, red or yellow. The bright, flowerlike bracts are not the true flower, but almost completely conceal inconspicuous small yellow flowers. Indian paintbrush wildflowers are also known as prairie-fire and grow in dry, sandy areas as well as moist areas. Indian paintbrush wildflowers can be found both on mountainsides and in open meadows.

Indian paintbrush wildflowers were adopted as the Wyoming state flower in 1917. The name comes from the fact that some Native American tribes used the bracts as paintbrushes.

The roots of Indian paintbrush wildflowers are partially parasitic and depend on other plant roots. Indian paintbrush wildflowers usually grow from one to two feet tall. Indian paintbrush wildflowers have the ability to grow in soils with high magnesium, low calcium and high amounts of metals such as chromium and nickel. Although they are edible, they will absorb selenium, and therefore cannot be eaten in large amounts when taken from selenium-rich soils.

The Chippewa Indians used Indian paintbrush to treat rheumatism and as a hair rinse. Both of these uses of Indian paintbrush wildflowers stem from the high selenium content in some paintbrush plants.

Snowberry Wildflowers: A Multipurpose Plant

Western snowberry wildflowers are part of the honeysuckle family. Snowberry shrubs grows up to 3' in height and spread through rhizomes, forming colonies of fruit-bearing plants. Snowberry wildflowers are white to light pink at the end of twigs and upper leaf axils. The common snowberry is a popular shrub in gardens due to its decorative white fruit.

Snowberry wildflowers are an important source of winter food for birds including quail, pheasant and grouse and are a famine food for humans due to their bitterness and the presence of saponins in the berries. Saponins, a substance also found in many beans, can be destroyed by cooking.

Saponins are quite toxic to some animals such as fish. Native Americans put large quantities of snowberries in streams and lakes as a fishing technique to stupefy or kill fish. An infusion of the roots from snowberry wildflowers has also been used for inflamed or weak eyes and to aid in convalescence after childbirth.

Snowberry bushes have extensive root systems and can be used to stabilize soils on banks and slopes. They tend to grow in open prairies and along streams and lakes in Montana, Washington, Utah, New Mexico, Minnesota and Canada.

The branches of the snowberry wildflower bush can be made into brooms. The bush is also very tolerant of trimming and can be grown as a medium to tall hedge.

Yucca Flower: State Flower of New Mexico

Yucca wildflowers are one of forty different species that inhabit the southwestern United States and Mexico. Some non-desert species also live in the southeastern United States and in the Caribbean Islands. Yucca flowers are

pollinated by a specific moth. In the absence of this moth, yucca flowers must be hand pollinated to survive.

Yucca wildflowers are in the lily family as indicated by their cream-colored, bell-shaped flowers. Yucca wildflowers are actually trunkless shrubs and are related to the cassava or tapioca family. Yucca wildflower leaves contain strong fibers that can be used to make ropes. Yucca wildflower roots contain a natural red dye used for baskets.

A tea from the yucca wildflower buds has been used to treat diabetes and rheumatism. The buds can be eaten like bananas. Yucca wildflowers can be cooked and ground for candy, called colache. The yucca wildflower is the state flower of New Mexico.

New Green

Soundlessly, we split the pod –
Two seedlings burrowing through a thawing earth,
fine hairs drinking snow melt,
roots growing toward a buried spring,
true leaves breaking the crust
and winding, unerringly, toward the light.

Patricia Doherty Hinnebusch

We can complain because rose bushes have thorns, or rejoice because thorn bushes have roses.
Abraham Lincoln

I'd rather have roses one my table than diamonds on my neck.
Emma Goldman

True friendship is like a rose: we don't realize its beauty until it fades.
Evelyn Loeb

A rose is a rose is a rose.
Gertrude Stein

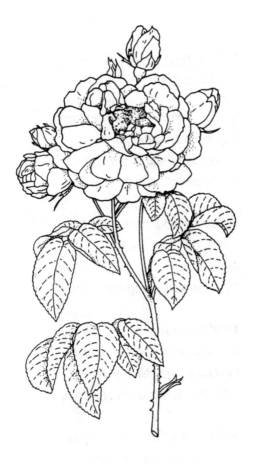

Rose

A Red, Red Rose
by Robert Burns

O my Luve's like a red, red rose
That's newly sprung in June;
O my Luve's like the melodie
That's sweetly played in tune.

As fair art thou, my bonnie lass,
So deep in luve am I;
And I will luve thee still, my dear,
Till a' the seas gang dry:

Till a' the seas gang dry, my dear,
And the rocks melt wi' the sun;
I will luve thee still, my dear,
While the sands o' life shall run.

And fare thee weel, my only Luve,
And fare thee weel awhile!
And I will come again, my Luve,
Tho' it ware ten thousand mile.

CHAPTER 9
Healing with Flowers

Flowers have been used as healing agents for thousands of years. Flowers can be used as herbs, essences or essential oils. Many flowers are edible, adding nutrients and interest to any meal. The positive psychological effect of flowers has also been documented in a variety of studies. Flowers appear to increase social interactions, decrease food intake and generally uplift the emotions.

Flowers As Herbs
The list of flowers used for herbal remedies is extensive. A few of the more prominent floral herbs are below:

Calendula - Used in skincare for healing sores and wounds and for fighting fungal infections. Often infused into oil for creams and salves.

Chicory - Used as a tonic, diuretic and laxative. Chicory root may be dried, roasted and ground for a coffee-like beverage.

Chives - Used to rid the body of parasites, to treat anemia and to support the immune system. Chives are also known for promoting the health of the circulatory system.

Dandelion - Used to cleanse the body, especially the liver. Dandelion is considered to be a spring tonic for the digestive system and the elimination system.

Dill - Used as a stimulant for the digestive system. Dill assists with constipation and all other symptoms of indigestion.

Fennel - Used as a digestive aid, especially for colic and flatulence. Fennel traditionally has also been used to stimulate menstruation.

Lavender - Used to calm, soothe and induce sleep. Lavender sachets are used to keep clothing and bed sheets fresh-smelling.

Red clover - Used to support bone health and minimize the effects of menopause. Red clover is high in nutrients and is a rich source of isoflavones, an estrogen-like chemical.

Roses - Used as a mild astringent and as a tonic for the throat and mouth ulcers. Rose water can be used for chapped hands, faces or lips.

Violets - Used as an expectorant and to assist with the alleviation of respiratory disorders. Violet tea has been used for insomnia and for a mild laxative effect.

The Healing Power of Flower Esssences

The most well-known use of flower essences is the work of Dr. Edward Bach. Dr. Bach, a London physician in the 19th century, believed that disease is a manifestation of negative mental states. He classified all negative states into seven major groups. Each of these groups had certain flower essences that would help to dispel the negative state and thus bring about physical, emotional and mental healing. These states were also related to a pair of complementary

colors. A few drops of the diluted remedies, similar to homeopathic remedies, are taken daily until the condition is alleviated. There are Bach flower remedy practitioners carrying his work forward all over the world today. See the list of mental states and associated with specific flower essences below.

Negative Mental State: Uncertainty
Associated Color Symbolism: Red/Green
Associated Flower Essences:
Cerato - lack of trust in one's own decisions
Scleranthus - inability to choose between alternatives
Gentian - discouragement after a setback
Gorse - hopelessness and despair
Hornbeam - procrastination, tiredness at the thought of doing something
Wild Oat - uncertainty over one's direction in life

Negative Mental State: Loneliness
Associated Color Symbolism: Pink/Green
Associated Flower Essences:
Water Violet - pride and aloofness
Impatiens - impatience
Heather - self-centeredness and self-concern

Negative Mental State: Oversensitivity to Others
Associated Color Symbolism: Orange/Blue
Associated Flower Essences:
Centaury - the inability to say 'no'
Walnut - protection from change and unwanted influences
Star of Bethlehem - shock

Negative Mental State: Despondency and Despair
Associated Color Symbolism: Orange/Blue

Associated Flower Essences:
Agrimony - mental torture behind a cheerful face
Holly - hatred, envy and jealousy
Larch - lack of confidence
Pine - guilt
Elm - overwhelmed by responsibility
Sweet Chestnut - extreme mental anguish
Willow - self-pity and resentment
Oak - plodder who keeps going past the point of exhaustion
Crab Apple - the cleansing remedy, also for self-hatred

Negative Mental State: Lack of Interest in Circumstances
Associated Color Symbolism: Golden Yellow/Turquoise
Associated Flower Essences:
Clematis - dreaming of the future without working in the present
Honeysuckle - living in the past
Wild Rose - drifting, resignation, apathy
Olive - exhaustion following mental or physical effort
White Chestnut - unwanted thoughts and mental arguments
Mustard - deep gloom for no reason
Chestnut Bud - failure to learn from mistakes

Negative Mental State: Fear
Associated Color Symbolism: Yellow/Violet
Associated Flower Essences:
Rock Rose - terror and fright
Mimulus - fear of known things
Cherry Plum - fear of the mind giving way
Aspen - fear of unknown things
Red Chestnut - over-concern for the welfare of loved ones

Negative Mental State: Overcare for Others
Associated Color Symbolism: Magenta/Green

Associated Flower Essences:
Chicory - selfish, possessive love
Vervain - over-enthusiasm
Vine - dominance and inflexibility
Beech - intolerance
Rock Water - self-denial, rigidity and self-repression

Aromatherapy: Essential Oils from Flowers

Another common way to use flowers for healing is essential oils. Essential oils are the most concentrated form of the active ingredients present in flowers. The comforting and uplifting aspects of flowers are all captured in the precious oils that are distilled from the buds, blooms and flower tops of various plants. Some examples of essential oils from flowers include the following:

Chamomile: Chamomile is relaxing and calming for the mind and body.

Clary Sage: Beneficial for the nervous system and female reproductive system.

Damascus Rose: Harmonizing for the mind and emotions.

Eucalyptus: Supportive for the respiratory system and the healing of wounds.

Geranium: Astringent and contractive. Supports blood coagulation.

Ginger: Promotes strong digestion and respiratory function.

Goldenrod: Supports the health of the cardiovascular and hormonal systems.

Helichrysum: An anti-coagulant also known for supporting memory and brain power.

Hyssop: Known as a disinfectant and nerve stimulant.

Idaho Tansy: A natural insect repellant, this oil also supports emotional wellness.

Jasmine: Considered to be an anti-depressant and to have anti-spasmodic properties.

Lavender: Relieves nervous tension and supports healthy sleep patterns.

Lemongrass: This oil has analgesic properties to assist with muscle, joint and tooth pain.

Orange Blossoms: Said to be both an aphrodisiac and to possess the ability to calm the nerves.

Patchouli: A musky fragrance useful for skin and hair care.

Ravensara: Supports respiratory health, especially when used in a diffuser.

Rose of Sharon: Calming to the nerves and elevating for the emotions.

Edible Beauty: Flowers You Can Eat

The use of flowers in food is also gaining a following. Flowers are particularly suited for salads, desserts and beverages. Some flowers, such as lavender, have a history of use with meats and poultry. Almost any edible flower is wonderful for garnishing and adding some color to a

meal. Keep in mind that not every flower can be eaten and that you will also want to avoid flowers that have been sprayed with pesticides. Growing your own edible flowers is probably the safest approach.

Some of the more popular edible garden flowers are begonias, calendula or marigolds, carnations, chrysanthemums, clover, cornflower, dandelions, day lilies, the English daisy, fuchsia, garden sorrel, gladiolus, lavender, lemon verbena, hibiscus, honeysuckle, impatiens, violas, lilacs, pansies, peonies, roses and many more. Other edible flowers from fruit trees include apple blossoms, orange blossoms, lemon blossoms, lime blossoms, grapefruit blossoms and elderberry blossoms.

In addition to the positive physical effects of floral herbs, essences and essential oils, the helpful emotional impact of flowers as gifts or for decorative purposes has been studied fairly extensively. Flowers have both immediate and long-term effects on emotions, social behaviors and even memory. Women receiving flowers report more positive moods up to three days later. Flowers given to men or women elicit more favorable social behavior. Flowers presented to the elderly have been shown to improve memory. Placing flowers on the dinner table can help to reduce the total food consumption, especially useful for those who are dieting. When two or more people are eating together, flowers can help to increase social intercourse and conversation, also cutting down on total food consumed.

Clearly, flowers provide a connection to beauty and constructive emotions in addition to the direct health benefits that they can convey. Although the role of flowers in healing is significant, the use of flowers purely to express symbolic and emotional intentions is by far their most common use. The fragrance of flowers and their inherent beauty are the quintessential language of friendship, joy,

pride, cheer, hope, sympathy, happiness, religious devotion
and love.

Leafing Out

Walk through woods
rendolent with wild flowers and herbs;
watch the moths and butterflies light

and flutter their brilliant wings.

Lie in green shade
inhaling the moist air;
hear the leaves swish and watch the birds
soar and swoop and perch and fly away.

Sleep in soft grass on the warming earth
amid the smells of life renewing itself
and exhale the sighs of your years

into the leafy air.

Your fondest memories will return,
fluttering their brilliant colors
and your heart will awaken and green

with possibilities.

Patricia Doherty Hinnebusch

ABOUT THE AUTHOR

Kathleen Karlsen, MA is an artist, writer, and design consultant. Kathleen has authored over 200 articles for print and online syndication. Her areas of expertise include symbolism, personal growth, spirituality, natural health, holistic education and fine art.

Kathleen's life journey has been focused on a spiritual search that has taken her through many philosophies and approaches to life. Her interest in symbolism stems mainly from her desire to discover how to use art, visual symbols, music and various forms of meditation and prayer to connect to the Source of all life and all healing.

Kathleen has a bachelor's degree in studio art and a master's degree in humanities. She has taught both art and music in classroom, studio and private settings. She lives in Bozeman, Montana with her husband Andrew, their five children, two cats and a pet tortoise.

SELECTED RESOURCES

Greenaway, Kate. *Language of Flowers*. 1884.

Lehner, Ernst and Johanna. *Folklore and Symbolism of Flowers, Plants and Trees*. NY: Tudor Publishing C., 1960.

Kate, Maggie. *Big Book of Plant and Flower Illustrations*. New York: Dover Publications, 2000.

Lovejoy, Ann and Jan Riggenbach. *All About Perennials*. Des Moines, Iowa: Ortho Books, 1999.

Lovejoy, Ann and Leona Holdsworth Openshaw. *All About Annuals*. Des Moines, Iowa: Ortho Books, 1999.

Schiemann, Donald Anthony. *Wildflowers of Montana*. Missoula, Montana: Mountain Press Publishing Company, 2005.

Vetvicka, Vaclav. *Wildflowers of Field and Woodland*. Winston, Leicester: Harvey's Bookshop Ltd and Arcturus Publishing Limited, 1990.

NOTE TO THE READER

This book was created from materials gathered over the course of nearly ten years of personal study. My work as a professional artist was the original inspiration for my interest in visual symbols, but my love of symbolism has now taken on a life of its own.

In our global world, symbolism can be a confusing topic. Various cultures assign diverse, sometimes opposing, symbolic meanings to the same plants, flowers, trees or other aspects of the natural world. Online symbolism resources come and go. Books go in and out of print.

In addition, an honest researcher must admit to the presence of unavoidable personal bias. My tendency, for example, is to emphasize the positive rather than the negative meanings associated with any particular flower or natural object.

If you would like to use material from this book, please contact me for permission. Credit should be given to the author, a copyright notification must be included and a link to my website at www.kathleenkarlsen.com is appreciated.

CPSIA information can be obtained
at www.ICGtesting.com
Printed in the USA
FFHW011548110619
52954358-58539FF